Creative Plastics

David Rees

creative plastics

A Studio Book

The Viking Press · New York

Acknowledgements

I would like to thank the Gloucestershire Education Committee's Craft and Design Adviser, and the Headmaster and colleagues of Filton High School for their encouragement and assistance in producing this book. I am indebted to Ken Stone for his assistance with many of the photographs and to Mrs V. Kenney for her patience and many hours of typing.

My thanks are also due to those who permitted me to reproduce photographs of their work (acknowledged in their places in the book). Also to the Electrum Gallery for supplying photographs of work done by Wendy Ramshaw, Claus Bury and Fritz Maierhofer.

The encouragement and assistance given to me by Leslie Summers are also gratefully acknowledged.

Acknowledgements are due to the Plastics Division of Imperial Chemical Industries Ltd for permission to print technical information and to reproduce photographs of Leslie Summers's work; to Lennig Chemicals Ltd and Trylon Ltd for their assistance with technical information; and finally to the Plastics Institute for kindly allowing their pamphlet to be used as a basis for the section on safety when using plastics.

I am particularly indebted to my wife, Vivien without whose help and understanding this book would never have been produced.

Published in 1974 by The Viking Press, Inc.
625 Madison Avenue, New York, N.Y. 10022

SBN 670–24682–4

Library of Congress Catalog card number: 73–8084

Set in Apollo 10 on 11 pt

Filmset and printed by
BAS Printers Limited, Wallop, Hampshire, England

Contents

1 Acrylics

The possibilities

In the past acrylics have been criticized on the grounds that the range of visual effects they give is limited. Fortunately less people than there used to be believe this to be true, and a brief consideration of the especial qualities of plastics in general should destroy any such assumption. In fact acrylics are becoming more and more acceptable as a creative medium for sculptors, goldsmiths and jewellers, that is to say, for those very

Symphony: height 37 in. (940 mm.) by slie Summers, 1972. Made from acrylic eet ⅜ to ½ in. (9 to 13 mm.) thick, heat ulded in a specially built electric en. The stresses set up in the material the shaping and cementing were moved by careful annealing hotograph courtesy of the Cork reet Gallery, London).

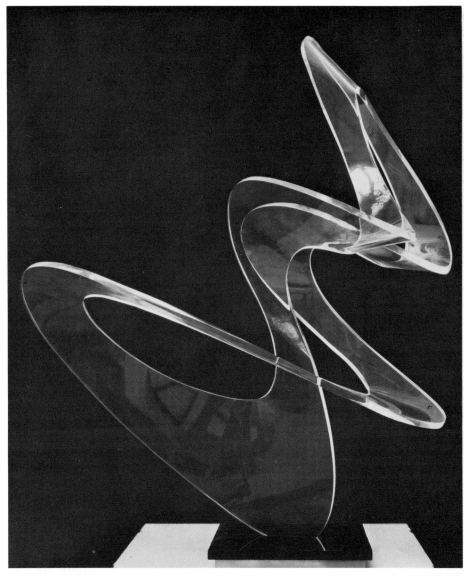

people who have used the old materials like stone, wood or metal. Claus Bury, Gerhard Rothmann and Fritz Maierhofer are just three artists who have had a formal training with traditional materials but in recent years have devoted their attention to the place of acrylics in jewellery and 'objects'.

What are acrylics?

These are a range of thermoplastic materials that have the appearance and many of the qualities of glass and are available in a wide range of trans-lucent or opaque colours. 'Perspex', 'Oroglas' and 'Plexiglas' are among the better known trade names of the acrylic material known to the scientist as polymethyl methacrylate.

Acrylics, being thermoplastic, will soften at a temperature between 150 and 160°C (334 and 352°F) and in this condition can be made to form many new shapes by bending, the possibilities of which are explained later. Also, when cool, the new form can be retained permanently unless the acrylic is reheated to above 80°C (176°F) when it will begin to assume its original form—a condition known as plastic memory.

Acrylic material is very much lighter than glass. Its surface is also very much softer but is comparable with that of aluminium. A simple way of determining the hardness of acrylic is by making a series of scratch tests with a graphite pencil: a 9H pencil scratches the surface but an 8H pencil does not.

Choosing acrylics

There can be many reasons why an acrylic material is chosen for a specific piece of work. The initial reason may be visual attractiveness. Disappointment could arise if after a year or more that beautifully crystal clear material showed signs of fading. Some acrylics are affected by ultra-violet light: the clear ones become cloudy after long exposure to ultra-violet light while coloured acrylics fade. It is important to enquire about the qualities of the acrylic since a graded sort is available to withstand exposure to ultra-violet light.

Acrylics are resistant to attack by many alkalis, dilute acids and aqueous inorganic salt solutions. They are not attacked by water to any significant degree though water absorption does take place. (For detailed information regarding chemical resistance of acrylic material, reference can be made to I.C.I.'s publication on 'Perspex' Properties.)

Care of acrylic sheet

Because acrylics can easily become scratched while working it is impor-tant that the protective paper covering remains on the surface until working with tools and machines is finished. Removing scratches from the surface of a sheet of acrylic material can be a lengthy polishing process. Hence careful working throughout the construction stage lessens the amount of time required for the final polishing. The edges are rather rough after sawing has taken place and the protective paper may have become slightly damaged, but do not be tempted to remove this paper

until the filing and scraping has been completed. If it is essential for the paper to be removed when heating the material then every precaution should be taken to avoid scratches.

Fluorescent effects

When the edges of certain coloured acrylic materials have been polished they will reveal a fluorescent glow. Also if an incision with a drill, engraver's cutting tool or even a scratch is made it will reveal a fluorescent outline. This effect can be used to accentuate movement and direction of form particularly in sculptural designs.

Tools

Hand tools: general

Many of the hand tools found in the conventional woodworker's or metalworker's workshop are suited to the cutting and shaping of acrylic material. Saws with fine teeth are preferable to those with large teeth, even if the cutting rate may seem a little slow. A saw such as the bow saw with approximately ten to twelve teeth per inch (four to five teeth per cm.) is not only more difficult to control but very easily causes chips of acrylic to break away from the edge. The coping saw blade with approximately sixteen to eighteen teeth per inch is much more successful. The only point to remember is to cut at a steady speed and prevent the blade from getting too warm by resting after a dozen or so strokes. If the blade becomes fixed in the cut it means that the acrylic has softened from the heat and the blade has then become set as the material cools. With steady pressure the blade can be easily released without damage to it or the work.

The ordinary hand drill and twist drill is adequate for drilling holes of small diameter. For holes larger than $\frac{1}{4}$ in. (6 mm.) wide it may be necessary to use a hand power drill or a sensitive pillar drill. With the faster speeds of cutting generating greater heat, it is necessary to raise the bit clear of the work several times during a simple drilling operation.

The next most useful hand cutting tool is an engineering file. With these three types of tools, i.e. saw, drill and file, acrylics can be fashioned into many new and varied shapes. The machine tools do, however, speed up many of the cutting operations and permit a greater degree of accuracy.

Cutting sheet acrylic with a hand tool

The Rohm and Haas Company have produced a hand cutting tool for cutting sheet acrylic on a principle similar to that used for cutting glass. A line is scored along the sheet at the point where it is to be cut and then pressure is applied, so that the sheet breaks along the line, this being the weakest part of the sheet.

Hold the tool between thumb and forefinger and draw it across the sheet three or four times, a metal straight edge or steel rule being used to guide the cutting blade. It is essential that a single clean groove is produced for good results. Then place the work over the edge of a table or bench with the groove immediately above the edge. Steadily press the overhanging

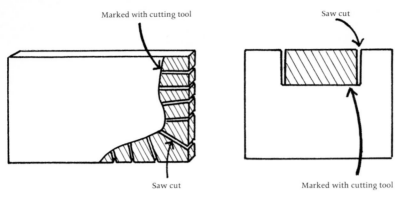

Marked with cutting tool

Saw cut

Saw cut

Marked with cutting tool

2 How to remove waste from acrylic sheet with a curved design.

part of the sheet while keeping the remaining part of the sheet firmly flat on the table top. With increased pressure the acrylic should break cleanly along the groove. The finish of the edge should be such that only a light rubbing on an abrasive paper is necessary to make it ready for polishing.

This method of cutting is highly suitable for acrylics up to $\frac{1}{8}$ in. (3 mm.) thick; for sheets up to $\frac{1}{4}$ in. (6 mm.) it is necessary to score both surfaces of the sheet to produce a clean break. Normally the protective paper need not be removed for this operation but where it is necessary to produce grooves on either side of the sheet it may be helpful to remove it in checking the alignment on clear or translucent sheets.

Other sheet plastics can be cut with this tool. It is advisable to try on a waste piece before attempting on the actual work, but quite often results are outstandingly good.

Limitations: there must be a surface area of the plastic sheet sufficient for the operator to hold firmly onto the flat surface and to apply pressure on the part overhanging the flat surface. If the amount to be removed is a long narrow strip, e.g. 1 ft. (300 mm.) long by $\frac{1}{2}$ in. (12 mm.) wide, then sawing is a more suitable method of cutting the sheet.

Curved lines

Curved lines can be scored on the surface of the acrylic but since it is necessary to deepen the groove by drawing the tool through it several times, a template (a plate in the desired design) is necessary to guide the cutting tool. Even with the curved lines carefully produced, applying the correct amount of pressure is not easy, and it is only possible to cut very gradual contours with this method.

Cutting curved contours near the edge of a sheet is possible using a cutting tool of this kind if cuts are made with a saw to assist in the removal of the waste. Score the curved contour on the surface first of all and then make a series of cuts with a saw perpendicular to the curved line. Remove the waste bits individually, or, if they are small enough, with a pair of pliers.

3 Cutting tools for acrylic: the Rohm and Haas one (*right*) and one made from a broken hacksaw blade. The dip coating method (*see* chapter 6) was used for the handle.

10

How to make a hand tool

The Rohm Haas cutting tool is not available in all countries but it is quite easy to make one.

A blunt or broken hacksaw blade is ideal as a cutting tool. First remove the teeth on a grinding wheel or, if a grinding wheel is not available, on a carborundum stone. Then grind the blade to the shape shown in Fig. 3 and sharpen the leading edge.

Fitting a handle

There are several ways in which a handle may be fitted and the method chosen may have to be determined by the facilities available.

If plastic coating is possible then this will be the simplest and quickest method of providing a handle. Round out the very sharp corners on a carborundum stone or wheel, and clean the surface to be coated with a degreasing agent. (Trichloroethane, in properly ventilated conditions, is recommended; do not use carbon tetrachloride.) Next, heat the blade in the oven—a domestic oven is suitable for the purpose—to a temperature of 180°C (388°F), then dip it in a fluidizer (see chapter on dip coating), and finally return it to the oven to allow the powdered plastic to melt. The process may be repeated several times to increase the thickness of the coating, but two or three coatings should be adequate to provide a cutting tool with a comfortable handle.

If dip coating facilities are not available fit a wooden handle on by glueing a piece of wood on each side, using a suitable metal to wood adhesive. Then shape the wood to provide a comfortable handle. Alternatively, wrap p.v.c. tape round the handle end of the blade.

Machine tools: general

Most workshop machines designed to cut either wood or metal are quite suitable for use on acrylics, e.g. the power drill with its jig saw, circular saw and polishing attachments. To avoid chips and fractures during cutting the material must be supported as near to the point of pressure as possible. Also, for the best results, the cutting angles should be similar to those for cutting brass, i.e. no top rake and 12° to 15° clearance. In most cases the usual cutting angles are adequate.

The main problem is that the friction can cause the acrylics to melt. This can be avoided by not applying too much pressure—with a light touch and constant movement of the acrylic sheet past the blade there should be no danger of ruining the material.

The circular saw

The circular saw is by far the most suitable machine for cutting along straight lines. The teeth should not be too large and for general use the ideal saw blade should have between eight and ten teeth per inch (three to four teeth per cm.) for $\frac{1}{8}$ in. (3 mm.) acrylic sheet and between three and five teeth per inch (one to two teeth per cm.) for $\frac{1}{2}$ in. (13 mm.) acrylic sheet or over. A 10 in. (250 mm.) diameter blade should run at a speed of about 4,000 revolutions per minute.

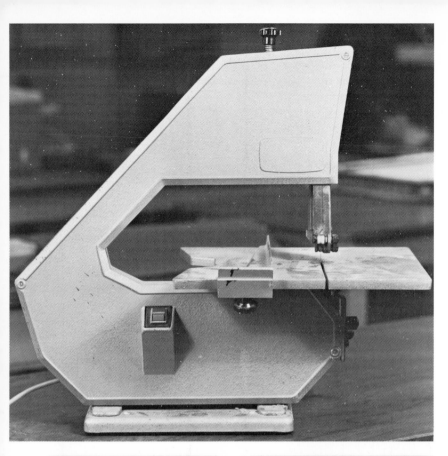

4 Small band saw suitable for cutting acrylic.

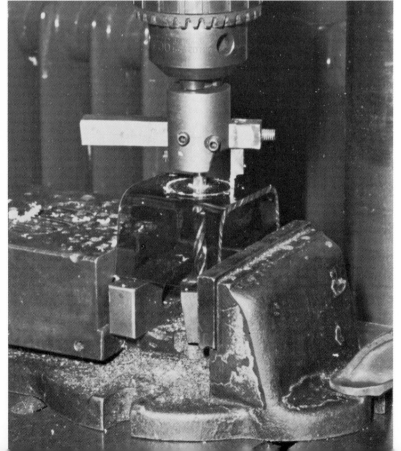

5 Cutting a $1\frac{1}{4}$ in. (32 mm.) diameter hole in a $\frac{1}{8}$ in. (3 mm.) thick piece of acrylic with an adjustable flycutter.

The tungsten carbide tipped blades give a superior finish to the edge of the acrylic sheet and do not require frequent sharpening as do the high speed steel blades. A sharp keen edge to each tooth of the blade is essential if chipping is to be avoided, but should it occur, even with a sharp blade, then either reduce the speed or reduce the rate at which the material is fed to the saw.

Some of the pigments used to colour the acrylics cause cutting tools to lose their keen sharpness, while the colourless acrylics have little effect upon the cutting edges of tools or the teeth of saw blades. So, as a general guide, where a lot of different coloured acrylics are to be cut the tungsten carbide tipped blades are recommended, but if only clear or colourless acrylics are to be cut high speed steel blades are quite adequate.

The height of the blade above the table of the circular saw should be just a little more than the thickness of the sheet to be cut. All the safety procedures normally used for cutting wood, plywood, hardboard, etc., should be adopted for the cutting of acrylics.

The band saw

For general cutting of acrylic sheet the band saw is perhaps most useful. Some band saw blades are designed specially for cutting wood and others for cutting metal. The latter is more suited to cutting acrylic because it has smaller teeth than those normally found on the woodworker's band saw. However, provided the blade has, for use on acrylic sheet $\frac{1}{8}$ in. (3 mm.) thick, between ten to twelve teeth per inch (four to five teeth per cm.), and for sheet of lesser thickness, sixteen to twenty teeth per inch (eight to ten teeth per cm.), there should be no real problems. The saw guides should be kept as close to the acrylic sheet as possible to prevent the blade from twisting. This will not only permit more accurate cutting but also a longer life for the blade.

The drill

Though drilling can be carried out satisfactorily for most work with a standard jobber's twist drill, the slow spiral twist drills give better results more easily. The included angle of the jobber's drill, which is approximately 118°, is too small for thin sheet and needs to be approximately 130°. If the thickness of the material is such that the chisel point of the drill does not go through the underside before the total cutting edge is in contact with the material (see diagram), there is little danger of the acrylic breaking.

When drilling, a piece of wood should be placed immediately beneath the point where the drill comes through, so maintaining maximum support for the material throughout the drilling operation. Of course, if a small hole is to be drilled a short distance into a block of acrylic, then the risk of fracturing is negligible. If a supply of cool compressed air is not available when drilling a hole care should be taken to avoid overheating. The swarf (waste cuttings) must be removed frequently by withdrawing the drill from the hole and allowing the bits to fall away from the drill. If the hole to be drilled is a deep one, it is advisable to use a lubricant.

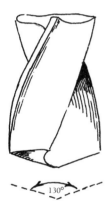

130°

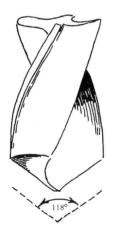

118°

6 The cutting angle for general use with a flycutter (*bottom*) and the preferred angle for use on acrylic (top).

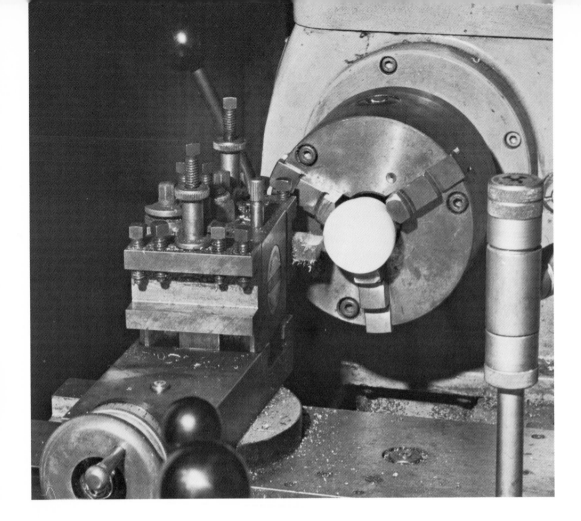

The lathe

7 Cutting acrylic on a lathe.

Acrylics are quite easily turned on either a woodworking or a metal-working lathe. Provided the usual care is taken to prevent the acrylic from overheating, good results can be obtained. The cutting tool needs to be really sharp and ground correctly. There should be no top rake and between 15° to 20° front or clearance rake. The cutting speeds can vary between fast speeds of 1,000 ft per min. (300 m. per min.) and much slower cutting speeds of as little as 75 ft per min. (22 m. per min.). Fast speeds are used for a quick removal of unwanted material and only if a constant supply of a coolant is available. The lower cutting speeds are used to produce a good quality finish and, if enough care is taken, there is rarely a need for a coolant.

The milling machine

Considerable work can be done on a milling machine providing there is a suitable means of holding the acrylic. The conventional machine vice is not the most suitable means of holding the work because it is either not large enough or it marks the surface with the serrated jaws. The most

suitable means of holding is with a number of toggle clamps or a double-sided adhesive cloth or paper tape.

The ordinary metal cutting end-mills are not the most suitable for cutting acrylics, because the rather shallow flutes tend to become clogged with the swarf. Instead the fly cutters or tools with a wide pitch, no front rake, and between 15° to 20° clearance are necessary.

The power router

(Not allowed in schools; recommended for professional use only.) This tool was primarily designed for machining wood but with the advent of acrylics it has become yet another tool or machine suitable for cutting synthetic materials. The spindle speed is very high and constant care must be taken to avoid overheating. A spoon-type cutter is ideal for cutting grooves or slots up to $\frac{1}{2}$ in. (12 mm.). If the router is mounted in a stand it can be used for trimming the edges of acrylics.

The spindle moulder

(Not allowed in schools; recommended for professional use only.) This machine is also useful for trimming the edges of acrylics though originally conceived for spindle moulding wood. Because of the side cutting action the swarf is readily removed and overheating is no real problem, so these machines rarely require a cooling system.

Finishing and polishing

Once the article has been constructed and no more machining, fixing or forming has to take place then one may want to polish the edges. In the case of sheet material, if the surfaces have not been machined or worked in any way and the protective paper covering has remained intact, there is seldom any need for polishing to take place, since the sheet has already been manufactured in a highly polished condition.

Edge finishing and polishing are quite common however. The rough edges left by the saw need to be trimmed so that all the marks are removed and a mirror-like finish given to the edges. As in all finishing operations, the principle is to remove all the coarse scratches and cuts by finer and finer ones until they can hardly be seen. This is done by using either a number of graded engineer's files or abrasive papers.

The grinding disc

A quick and very effective way of removing coarse marks is by grinding the edges on an abrasive disc, either mounted on a bench rotating in a vertical plane or on the spindle of a woodworker's lathe. (For this, a face-mask should be worn as a protection against dust.) A medium grit garnet paper is recommended for general use. A platform on which to rest the work is essential. The disc can rotate at the spindle speed of the motor at approximately 3,000 revolutions per minute. The work is carefully pressed against the half of the disc which is moving in a downward direction in relation to the platform and then steadily moved across it. Care is taken to avoid the work rubbing on one part of the disc otherwise

8 Scraping the edge of acrylic sheet to remove the fine scratches left by abrasive paper, and to give a frosted finish.

the abrasive becomes clogged with acrylic dust and eventually the frictional heat causes damage to both sheet and disc. A badly worn or clogged disc will not improve the condition of an edge being ground and should therefore not be used. If the particles clogging the abrasive disc can be removed with a stiff brush, this should be done regularly to gain the maximum use out of it. Also, all grinding must be done dry. Once the scratches have been reduced to the size of those made by the finest grade of available abrasive, the next stage is scraping.

Scraping can be done with a tool made from an old hacksaw blade. A cabinet maker's scraper will also do the job very well but will most certainly need to be resharpened before it is fit for scraping wooden surfaces again. Good results can be obtained by using a 'wet and dry' abrasive, such as 220 or 400 grit silicon carbide paper.

9 Edge grinding and edge polishing acrylic.

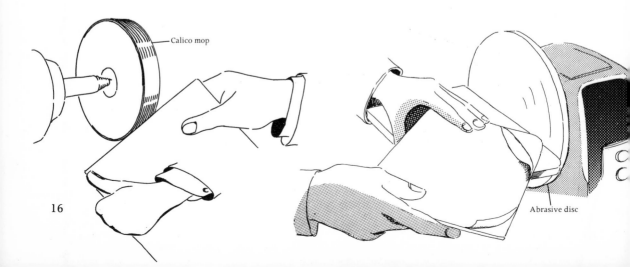

Calico mop

Abrasive disc

Mechanical polishing

This is the final stage and is mostly applied to the edges of sheets after they have been scraped. Polishing is performed best on a mechanically driven buffing wheel. The stitched leaf calico buff from 6 in. (150 mm.) to 10 in. (250 mm). diameter is suitable for a buffing machine with a spindle speed of approximately 1,500 r.p.m. The faster surface speed of the larger buffing wheels must be allowed for when polishing, and a much lighter pressure must be given to the work.

The buffing wheel need only be dressed with a fine abrasive (an excellent example is jewellers' rouge). A final cleaning on a swansdown mop provides a lustrous finish to the surface of the acrylic sheet.

Hand polishing

Surfaces of acrylic sheet are not normally polished because they have already been provided with an unblemished mirror-like excellence. However, for the removal of very light scratches or surface blemishes, polishing is possible with a pad of cotton wool rubbed by hand over the blemished area in a circular motion. Only small quantities of polish are required and frequent changes of cotton wool pads are necessary in order to produce the desired surface. Too much pressure can cause the development of an orange peel effect.

If the scratches are too deep for a light polishing to remove them it will then be necessary to use a Grade 000 wet and dry silicon carbide paper. The paper must be attached to a cork sanding-block and applied to the blemished area wet. The affected area is rubbed with a light, circular movement, the paper and the block being kept wet until the operation is complete. With the deeper scratches removed the surface can be treated with the hand polishing process described in the previous paragraph.

A simple device for polishing the insides of holes in acrylic sheet: make a fine saw cut in a piece of dowel $\frac{1}{2}$ in. (12 mm.) diameter and fix a strip of abrasive cloth in it. Mount the device in a pedestal drill and set it to revolve at 750 r.p.m. (faster speeds may cause overheating).

Other polishing methods

Solvent polishing is a most useful method for thin and intricate work and work that could not be polished by any of the methods just described. However it does entail dipping the work in a solvent polishing bath containing trichlorethylene vapour which does produce certain health hazards and is not recommended for use unless the precautions are completely understood and adhered to.

Flame polishing, in which the work passes through an oxygen–hydrogen flame, is another method. Although it does not produce the health hazards mentioned in the previous paragraph, it can cause crazing and discolouring to the acrylic material. The final result is not usually as good as that obtained from buffing.

Cleaning acrylics: general

If the acrylic is wiped with a dry cloth as in the case of normal dusting dust particles cling readily to the wiped surface and no amount of wiping

17

will remove them. This is because the acrylic material has become electro-statically charged. To solve this problem, dampen a cloth with a dilute solution of an antistatic polish such as I.C.I.'s 'Perspex' Polish No. 3, wipe it softly over the acrylic and then rub it with a dry cloth. Acrylic treated in this way will not be electrostatically charged and a dust-free surface will result. If the acrylic is washed in a solution containing 10% 'Perspex' Polish No. 3 and 90% water, the acrylic remains uncharged for approxi-mately two months and normal dusting can take place. If, however, the acrylic is washed then it must be treated with the polish again to restore its antistatic quality.

Acrylics and heat

When acrylics are heated to temperatures between 150 and 160°C (334 and 352°F) they take on a rubbery character and thus can easily be folded, stretched or twisted. Once the acrylic is allowed to cool it regains its rigidity and firmness without any signs of cracking or discoloration. It can be heated many times before obvious signs of degradation appear in the material.

Heat may be applied in two main ways, either by local heating, where the heat is applied to a confined area, say a straight line in preparation for a bend or fold, or by general heating, where the whole acrylic material is heated uniformly to produce a free shape, a gradual curve or a hemi-sphere.

Local method

All that is required is a single element heater. This can easily be made from a length of coiled element carefully embedded in an asbestos base (*not* asbestos cement sheets as these will crack and explode). The power required is approximately 1 kW. per 4 ft. (1 kW. per 1·2 m.).

Before acrylic sheet can be heated the protective paper must be removed. If a mark is required to show where to bend or fold, a line can be drawn on the surface of the acrylic sheet with a felt pen, which may be removed later with a damp cloth.

The acrylic sheet is placed on the heater with the line of the fold immediately over the element. With thin sheets $\frac{1}{8}$ in. (3 mm.) and less in thickness it is necessary to heat the acrylic from one side only; for thickness over $\frac{1}{8}$ in. it is necessary to turn the work over to heat the opposite side. This ensures an even penetration of heat throughout the thickness of the material. To attempt heating thick material from one side only will result in the surface becoming overheated before areas towards the middle and the far side reach a suitable temperature for folding, and this causes the surface to bubble and lose its clarity.

Oven method

Many materials require heating in order that they may be worked. The blacksmith heats metal in a forge, the glassblower glass in a furnace. While in both these cases the materials have to be red hot before they become workable, fortunately the temperatures required for making

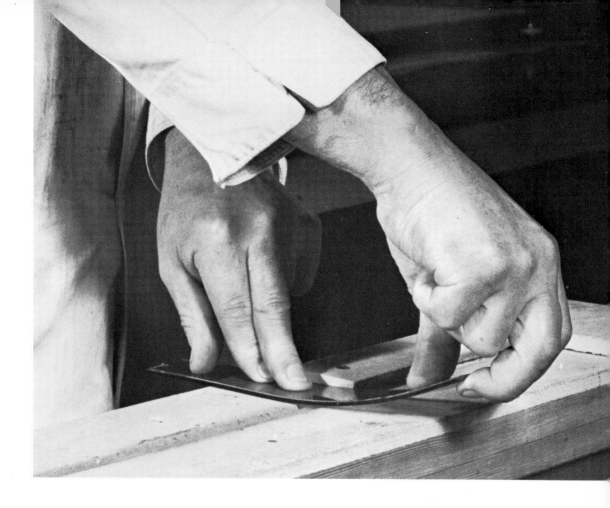

10 Heating acrylic for bending along a straight line.

acrylics workable are very much lower and work may be carried out without specialized equipment. An ordinary electric domestic oven with a thermostatic control is ideal for heating acrylic materials to a working temperature between 150 and 160°C (334 and 350°F).

To hold the hot acrylic safely is not a major problem. The protection for the hands is the same as the housewife would use during normal domestic cooking, for the temperature at which many foods cook is well above the temperature required to soften acrylics. If asbestos gloves or mittens are available they are ideal for handling hot acrylic material.

When the acrylic is soft and the highly polished surface easily marked, great care must be taken when the acrylic is being bent, folded or twisted. Pressure marks left by the gloves may not be desirable particularly if the material is coarse but, if need be, a fine, smooth linen cloth can be placed around the acrylic where it is to be held so that the minimum of marking takes place.

The shapes and forms that can be created this way are endless and very little imagination is required to produce interesting and exciting designs. The flat shape has to be considered first. It is drawn on the surface of the acrylic with a felt pen and cut out on the band saw, fret saw or whatever is available to cut out the shape. If the edges are to be polished then filing,

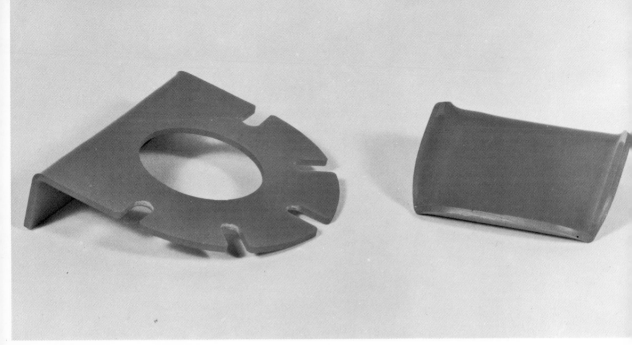

11 A tooth brush rack and soap dish made by the strip heater method.

scraping and polishing should take place before any bending and twisting, etc. Polishing can be done after the bending and twisting but only with some difficulty.

Projects

The bathroom

Acrylic, because of its particular qualities, i.e. crystal appearance, ease in working and resistance to moisture, make it an ideal material for use in the bathroom. Already baths and hand basins are made from an acrylic, proving to be highly successful. However, the reader need only concern himself with the making of ancillary furniture and fittings since these are well within his scope.

Items to be made: soap racks, tooth brush racks, face flannel holder, mirror stand, panels, shelves and a stool.

The dining table

The crystal translucency of acrylic make it an attractive material to have on a well laid out table. It requires very little effort to keep it clean and highly polished.

Items: napkin rings, table mat stand, salad servers, sugar tongs, toast rack, egg cups.

12 Objects for the bathroom.

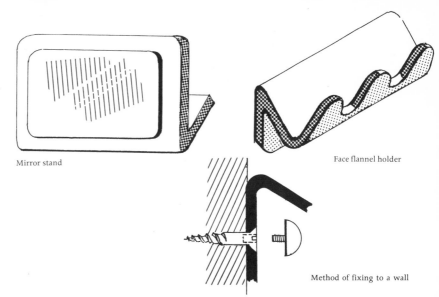

Mirror stand

Face flannel holder

Method of fixing to a wall

13 Wooden bending jigs with heated acrylic sheet (*top*), and acrylic wrapped round wooden formers and held in position with a strip of linen and a paper clip (*bottom*).

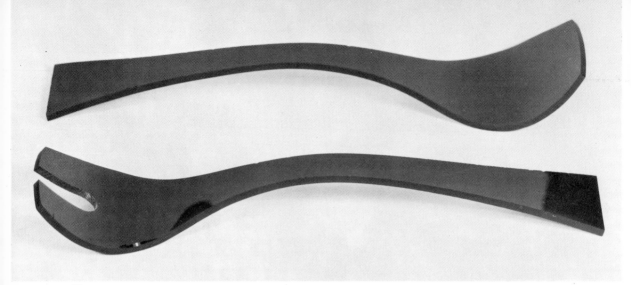

14

15

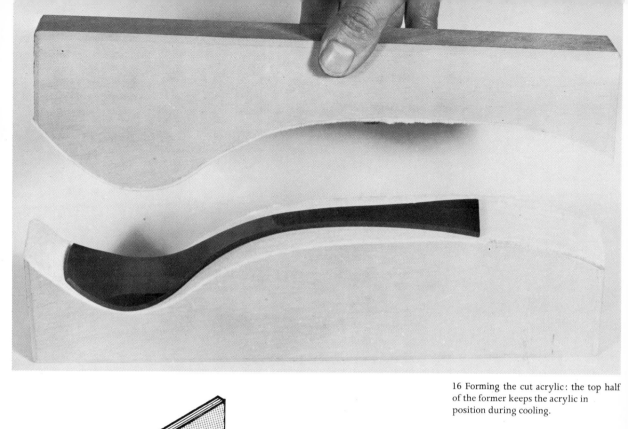

16 Forming the cut acrylic: the top half of the former keeps the acrylic in position during cooling.

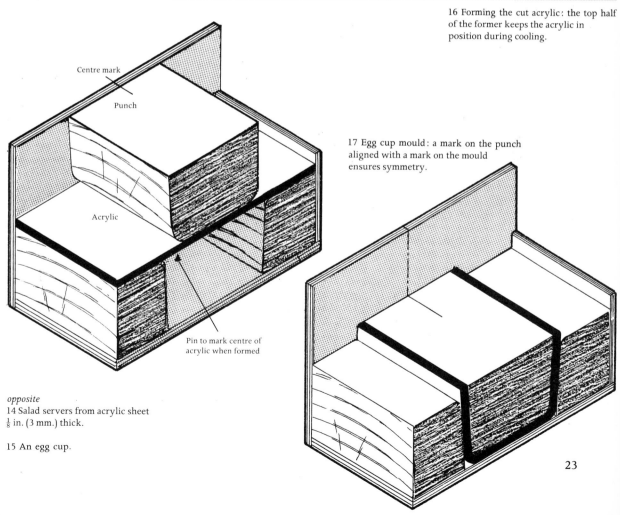

Centre mark

Punch

Acrylic

Pin to mark centre of acrylic when formed

17 Egg cup mould: a mark on the punch aligned with a mark on the mould ensures symmetry.

opposite
14 Salad servers from acrylic sheet
$\frac{1}{8}$ in. (3 mm.) thick.

15 An egg cup.

23

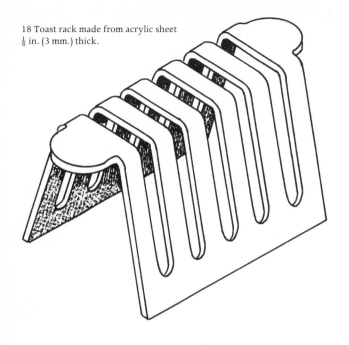

18 Toast rack made from acrylic sheet $\frac{1}{8}$ in. (3 mm.) thick.

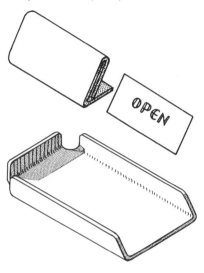

19 Card display and a letter tray from acrylic sheet $\frac{1}{8}$ in. (3 mm.) thick.

OPEN

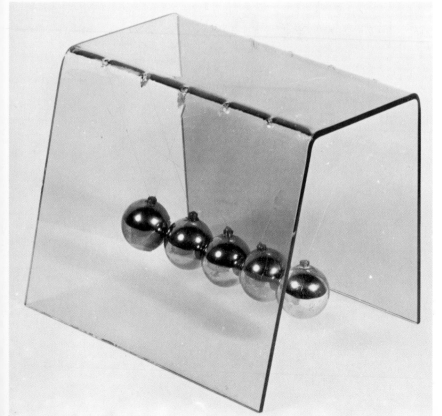

20 Newton's cradle (*left*) made with an acrylic frame.

opposite
21 Acrylic and silver bracelet designed by Fritz Maierhofer (photograph courtesy of the Electrum Gallery, London)

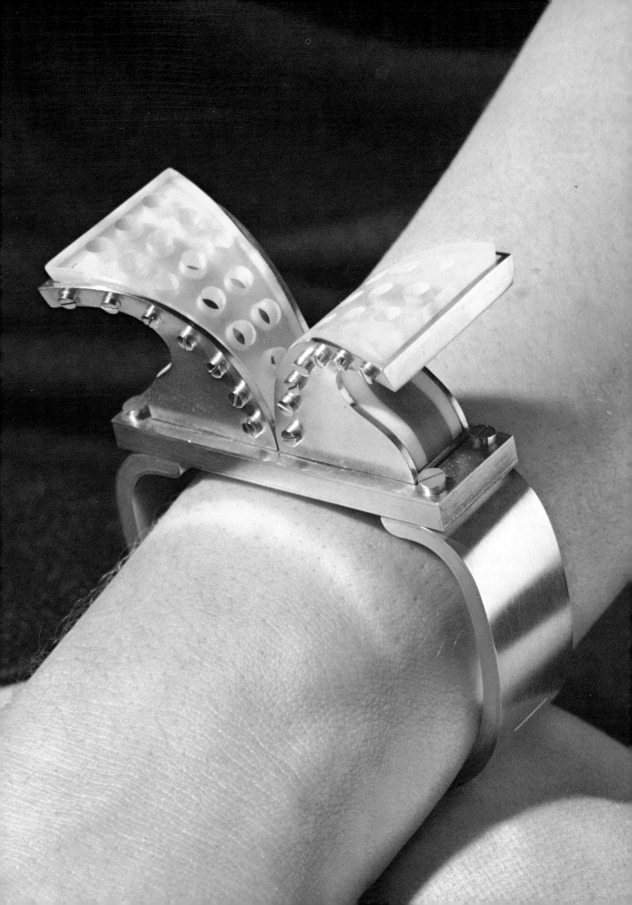

Using jigs or moulds

The simplest form of mould is a block of wood gently hollowed. For a smooth unblemished finish to the acrylic cover the mould with a soft cloth. With the acrylic sheet cut to shape and edges polished (if desired) lay it across the mould and gently heat it to the necessary temperature in the electric oven. The weight of the material alone is sufficient to cause it to adopt the curvature of the mould, although it is important that the work cools slowly and uniformly so that bowing or buckling does not occur. For curvatures such as shown in the diagram there is seldom any need for a retaining frame to be used.

Hold the acrylic in place while cooling by laying a piece of soft cloth immediately next to the exposed surface and then putting a block with a corresponding convex curve to rest on the cloth. Wood, being an insulative material, allows the acrylic to cool slowly and by nature of its weight assists in keeping the acrylic true to the shape of the mould. Weights may be added if this is felt necessary.

To make a cylinder from sheet acrylic

To do this accurately it is necessary to have or make a split cylindrical mould and a tapered clamp. This mould is made from a heavy gauge tin-plate material or a lightweight gauge mild steel sheet, and consists of two identical cylindrical halves hinged along one edge, whose internal diameter will be the same as the external diameter of the cylinder formed, so that for each size and diameter of cylinder required it will be necessary to have a separate mould. First cut the acrylic carefully to the right size. Then heat it in the oven until it is quite soft and place it in the mould so that the join of the cylinder does not coincide with the hinge or the open edge of the mould.

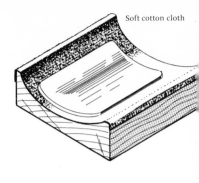

Soft cotton cloth

22 Mould for forming shallow curves.

23 Acrylic cylinder and metal mould.

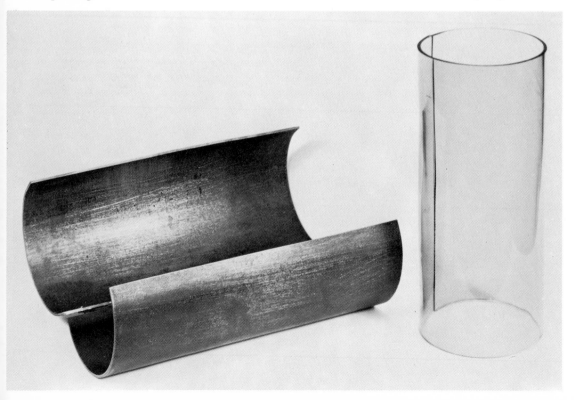

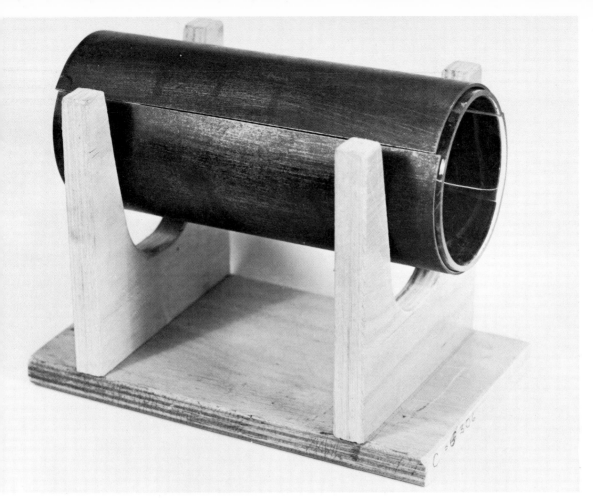

Mould for forming cylinder held in a

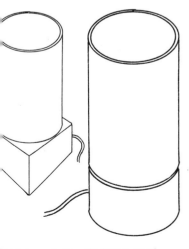

Table lamp designs, the base in wood the shade in acrylic.

Then put the mould in a jig with tapering sides so that the cylindrical mould is kept closed during the cooling period. The amount of time required to make a mould and jig is only warranted if a number of fairly accurate cylinders are required. To produce a single cylinder use a cardboard tube.

Cement the open edges with an acrylic cement. Before the edges are joined it might be necessary to file them to make a perfect joint. Providing the two edges are touching along their entire length there is no need for pressure to be applied while the cement is setting.

Such a cylinder may be used for these simple table lamp designs. The base is made from a piece of well-seasoned hard wood turned on a woodworker's lathe. With a suitable size of rounded jig, bracelets and napkin rings can be made while for the imaginative the rings and tubes can be used to create interesting three dimensional forms.

Acrylic bracelets and bangles

Mark out a rectangle approximately $7\frac{1}{2}$ in. (190 mm.) long × $1\frac{1}{2}$ in. (38 mm.) wide in pencil on the protective paper covering.

Cut the long side with the acrylic cutting tool, using a metal straight

27

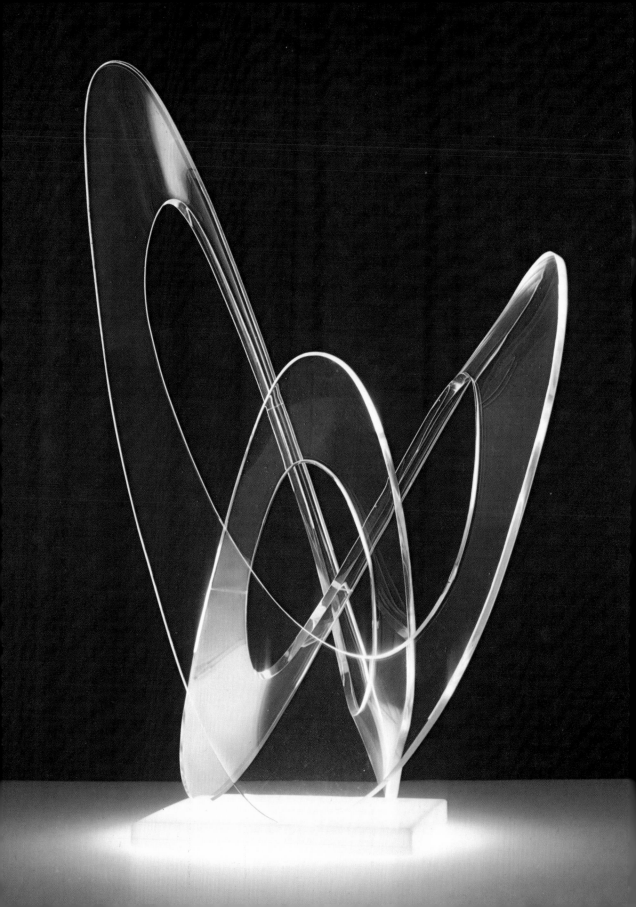

Winged Victory: height 39 in. (1 m.)
...eslie Summers. Illumination from
...w highlights the 'edge glow'
...otograph courtesy of I.C.I. Ltd
...tics Division).

...imple bracelet designs from acrylic
...et ⅛ to ⅜ in. (3 to 9 mm.) thick.

edge to provide a straight line. The edges will require very little rubbing down when an acrylic cutting tool is used. However, they must be smooth and polished at this stage. In the 'open pattern' the ends should also be polished but with the closed pattern the ends must be clean and square to permit a good butt joint when the acrylic is bent.

Decoration

A simple design can be engraved on the acrylic before it is bent to form the bracelet. On translucent acrylic the design may be engraved on the inside surface. This is particularly effective with acrylics that have the property of 'edge glow', for the lines show very clearly on the un-engraved outside surface.

A similar technique can be employed to produce a simple but effective design by drilling a series of shallow holes in what will be the inner surface of the bracelet. This again is particularly effective with acrylics that have edge glow. Straight lines can be produced with the cutting tool and straight edge.

When the design for the surface is complete the acrylic is ready for bending to form the bracelet. Remove the protective paper and heat the strip of acrylic in an oven to a temperature of 160°C (320°F). At this temperature the acrylic is soft and pliable yet care must be taken to avoid

28 Steps in making a bangle.

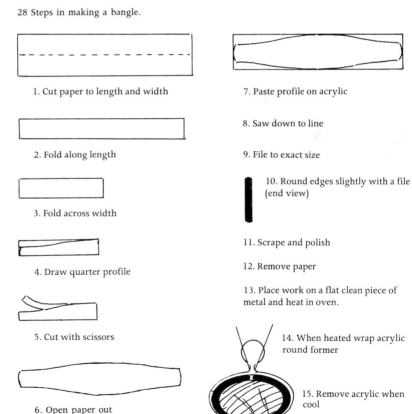

1. Cut paper to length and width

2. Fold along length

3. Fold across width

4. Draw quarter profile

5. Cut with scissors

6. Open paper out

7. Paste profile on acrylic

8. Saw down to line

9. File to exact size

10. Round edges slightly with a file (end view)

11. Scrape and polish

12. Remove paper

13. Place work on a flat clean piece of metal and heat in oven.

14. When heated wrap acrylic round former

15. Remove acrylic when cool

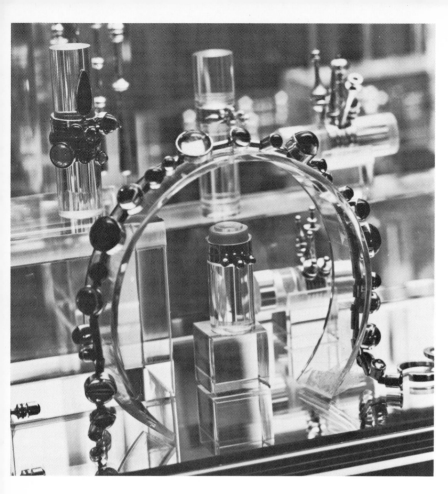

29 Modern jewellery by Wendy Ramshaw, attractively mounted on clear rod and block (photograph courtesy of the Electrum Gallery, London and by kind permission of I.C.I. Ltd Plastics Division).

30 Acrylic brooch designed by Claus Bury (1971). The brooch is mounted on an acrylic design on the wall, but is detachable (photograph courtesy of the Electrum Gallery, London).

marks being made on the smooth surface by gripping too hard. Place the heated acrylic on a piece of smooth cloth and gently wrap it round a suitable former (a glass bottle of a convenient diameter is ideal for this purpose). The smooth surface of the bottle does not damage the surface of the acrylic and its good conducting quality cools the acrylic quickly without harming it.

The closed pattern requires that the ends be cemented into position (see next section for how to prepare the material). Masking tape is used to protect the polished surfaces and to keep the two ends together, while leaving a small gap of $\frac{1}{32}$ in. (1 mm.) which is ideal to allow the cement to flow between the two ends. On the inner surface turn the masking tape up at the edge to provide a small wall. Apply the cement carefully with a dispenser until the gap is completely filled, making sure that there are no air bubbles and the level is just higher than the surface of the acrylic. When the cement hardens it will shrink and this level should fall to that of the acrylic surface.

The cement hardens within thirty minutes but it is advisable to leave it for longer before the final polishing.

Remove any blemishes caused during the bending and cementing stages by rubbing with a fine abrasive and buffing on a polishing mop.

Bonding

General

With the large variety of plastics on the market today there are also large varieties of adhesives or cements for bonding. Each of these plastics requires a particular adhesive and it is important that the correct one is used for any given material. Their manufacturers usually present in their sales literature a chart indicating the name, number or brand, etc., that is suitable for joining two pieces of a particular plastic, and also indicate the adhesives suitable for bonding one type of plastic with another or with other materials such as wood, metal, paper and fabric. It is essential to consult these charts when selecting an adhesive.

The first function of any adhesive is to bond successfully the parent material. The second function is to withstand the conditions to which the parent material is to be subjected, e.g. water, sunlight and abnormal temperatures. Some adhesives break down after a time if they are not made to withstand continuous or repeated exposure to any of these conditions. Ultra-violet light, as emitted by the sun and artificial sources, does cause some adhesives to deteriorate over long periods. So a second selection process has to be made to ensure not only a good bonding but also that the bond will withstand particular conditions.

Though strength values are not published with the general sales materials, data sheets are usually available on request from manufacturers.

General preparation

The surfaces of the material to be bonded must be free of grease and dirt. Where solvents are used to remove grease care must be taken to use only recommended liquids and usually in well ventilated rooms. Carbon tetrachloride, though an excellent degreasing agent, gives off toxic vapours that can be harmful and should never be used. Ordinary detergents, such as are used in washing-up liquids, are by far the safest, being neither toxic nor inflammable.

When using clear acrylics it is essential that the adhesive only be applied to the bonding surface. If the highly polished surface is affected by a stray drop, it immediately becomes damaged by the solvent contained within the adhesive and the original condition cannot be regained.

Masking

Masking tape or low-tack self-adhesive tape about $\frac{1}{2}$ in. (12 mm.) wide is ideal for masking, for the adhesives on the tape do not attack the plastics and therefore, when removed, leave no trace of their presence. Water-based spray coatings are also ideal for masking areas immediately round the joint and can easily be removed with a wet cloth after the adhesives have set or cured.

Adhesives come in tins, tubes, bottles and polythene containers, many with a limited life. A date indicating the time by which it should be used is often clearly marked on the container, but once a container has been opened the life of the adhesive is even more limited (the period in which

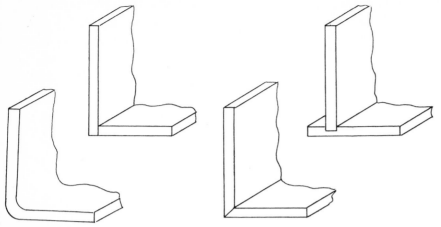

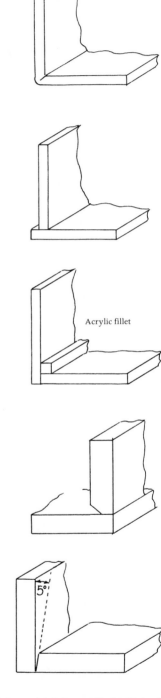

the adhesive remains usable being known as the 'shelf life'). Adhesives contain a highly volatile agent that vaporizes rapidly when exposed to the air so it is important that the container be sealed immediately after each occasion it is used.

Adhesives can be applied by a rod, brush or a bottle with a fine nozzle. If the adhesive is contained in a polythene bottle with a narrow pointed nozzle, it is easy to apply a controlled amount of adhesive to the required area without waste. The flexible sides permit a controlled pressure between fingers and thumb to force the adhesive out.

Cements

It is possible, but risky and certainly not to be recommended for students, to make acrylic cement by dissolving small chips of methyl methacrylate (acrylic material) in a solvent such as chloroform. Time must be allowed for the chips to be completely dissolved before it is used, but it should be ready the day after it is prepared. It is well to remember that the solvent is highly volatile and the preparation should be made in a bottle with an airtight seal.

I.C.I. produce among many other things a range of acrylic cements bearing the trade name 'Tensol', each of which has a number indicating its type and its most suitable use: Tensol Cement No. 3, No. 6, No. 7, No. 104.

Tensol Cement No. 3 is a two part cement. The clear liquid part is a stabilized methyl methacrylate monomer and the powdered part an acrylic polymer containing a catalyst, mixed together in the proportions recommended by the manufacturer. The hardening or polymerization process of Tensol No. 3 is increased if the cemented object is gently heated in an oven for two hours at 55°C (131°F) and at a temperature of 80°C (176°F) for a further eight hours. This cement also has strong binding powers and resistance to weathering conditions.

Tensol No. 6 is a one part cement used for general purposes. It is not, however, recommended for outdoor use. The cement hardens by polymerization at normal room temperature though the process can be speeded up by gently warming in an oven at approximately 55°C (131°F).

31 Corner joints for acrylic sheet (*above*) and method of cementing (*opposite*).

32

Photograph cube: five acrylic rectangles are accurately cut and cemented together. A cube of foam plastics cut on the band saw holds the photographs in position.

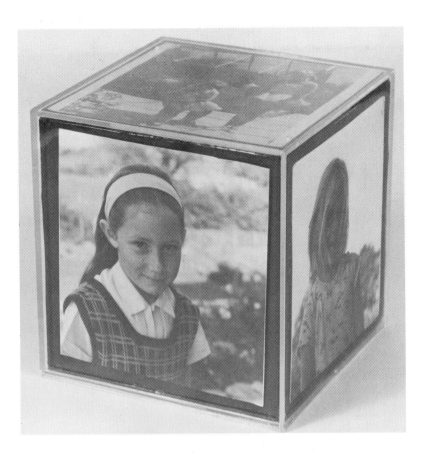

Masking tape

Uncured cement

Cured cement

Tensol cement No. 7 is a two part cement. Part A is a mobile monomer/polymer syrup and part B a liquid catalyst. When the two parts are mixed together polymerization begins almost immediately. The quantity required should be carefully assessed to prevent wastage and should be used within twenty minutes of its preparation. No heat is necessary to the hardening process, but may be used if a good bond is required in less than four hours.

Tensol cement No. 104 is used for laminating glass with glass or glass with acrylics. It is a flexible colourless cement and, if desired, can be hardened fully by heat at 55°C (131°F) for two hours, increased to 80°C (176°F) for a further four to eight hours, but a catalyst of 0·5% benzoyl peroxide must be added to the cement.

Process

Clean the surface of the acrylic thoroughly by rubbing lightly with a fine grade glasspaper or garnet paper. The acrylic surface adjacent to the joint must be protected from spillage or overflow with masking tape. Smear the areas to be joined with a thin coating of cement and bring them together as quickly as possible, i.e. without giving the cement any chance to set. Use masking tape to keep the two pieces bonded, particularly when

33

there is a tendency for the joint to spring open. The cement sets within one hour at a room temperature of approximately 20°C (68°F) sufficiently hard for the work to be handled and the masking tape removed. The cement hardens completely in 24 hours.

Acrylic rings

Rings can be made from a single piece of acrylic—either opaque or translucent, or a combination of both built up to form laminations.

The internal diameter of the ring is obtained by using a jeweller's ring gauge but for general use a $\frac{3}{4}$ in. (18 mm.) diameter drill will provide an average fit for an adult hand.

Marking out

On a piece of acrylic $1\frac{1}{2} \times 1\frac{1}{2} \times \frac{1}{2}$ in. ($38 \times 38 \times 12$ mm.) mark out in pencil on the protective paper the centre position of the finger hole. Draw two concentric circles from this position, one the diameter size of the finger hole and the other the outside diameter. The thickness of the ring needs to be not less than $\frac{1}{8}$ in. (3 mm.). The rest of the design for the ring can then be drawn. The side view must be drawn later.

Cutting out

Drill the hole first. It is far easier to hold the acrylic in a vice or jig when the opposite sides are parallel. (For drilling see p. 13.)

Cut the external shape with a band saw or a hacksaw. Leave sufficient material between the kerf and the pencil line to allow for 'cleaning up' and polishing, which can be done by using an engineer's file.

Polishing

The surface left by the drill should have little imperfection and only requires a light rubbing with a fine abrasive paper. This operation is best done on a drilling machine. In one end of a 6 in. (150 mm.) length of dowel rod approximately $\frac{1}{8}$ in. (3 mm.) less in diameter than the hole to be polished cut a saw. Wind a strip of abrasive paper round the end and grip it in the saw cut. Then mount the dowel in the drill chuck.

Polishing can be done using the same method but substituting for the abrasive paper a strip of flannel which has on it a suitable grade polish.

Reduction of thickness

Stick masking tape or any suitable adhesive paper to the outer edges and draw lines to show the required degree of reduction. Remove the unwanted material on a sanding disc.

Smooth all the outer surfaces with fine grades of abrasive paper. The wet and dry types are very good for producing clean surfaces ready for polishing.

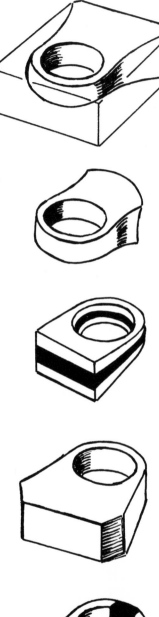

33 Rings from blocks and laminated acrylic (*top*) and how to mark out a ring (*opposite*).

Lettering on acrylic

This can be done in a number of ways and the choice of method may depend on the equipment available. The first two methods described and illustrated below need no specialist equipment at all and yet professionally high standards can easily be achieved.

Self-adhesive letters and numbers

Letters and numbers are available with a self adhesive back. All that has to be done is to remove the protective paper backing and press the letters onto the surface of the acrylic. Care must be taken to position the letters correctly and to try to obtain good spacing of the letters.

Application: Illustrative work indoors or outdoors. Sign posts, advertising and display. It is advisable to discover whether the self-adhesive letters are suitable for outdoor conditions when purchasing.

Ink dry transfer

The ink dry transfer method has been developed considerably during the last ten years, notably by 'Letraset'.

The ink letters are available on sheets or tapes and to protect the ink each sheet or tape has a siliconized paper backing. Remove this and position the required letter on the work. Register a guide line in water soluble ink drawn on the acrylic with a line on the letter sheet to ensure correct positioning. Then press the letter lightly with the finger and shade it all over with a ballpoint pen. When the sheet is pulled carefully away, it leaves the letter neatly transferred to the work. After all the lettering is completed, place the siliconized sheet over the work and burnish it moderately hard with the rounded end of the ballpoint pen. The water soluble ink guide line is carefully removed by rubbing lightly with a damp cloth.

Application: Display work in exhibition show cases. Signs and labelling of all kinds. Mainly suited to indoor rather than outdoor work.

Pantograph

Incised letter carving on acrylics and other plastic materials is commonly used today, which with a pantograph machine and a range of face type letters is quick and easy. Arrange the letters on the setting table and lock them in position. Clamp the work in position beneath the cutter and set the arm to give the desired size to the letters. The tracing needle follows the face type letters on the setting table and the cutting tool makes an identical movement on the work. The depth and sectional shape of the incised cut depends upon the depth setting on the machine and the shape of the cutter.

Lettering done on opaque acrylic can be made to show up clearly by painting a contrasting colour of cellulose paint in the incisions made by

× 1½ × ½ in. (38 × 38 × 12 mm.) ⅛ in. (3 mm.)

35

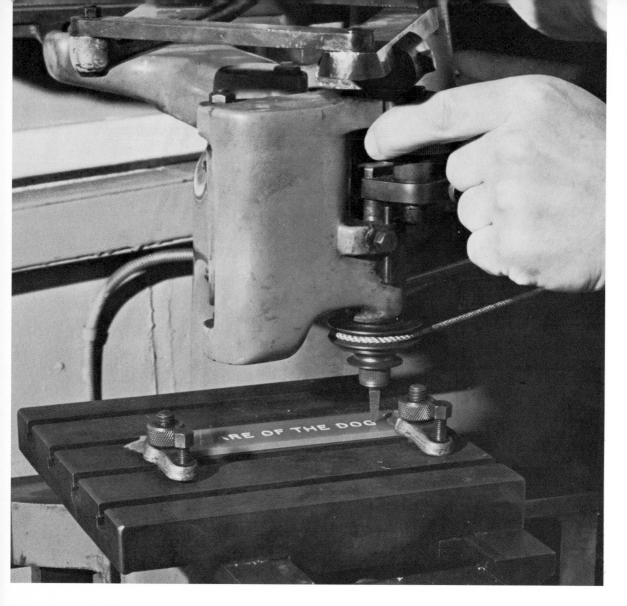

the cutter. Remove excess paint with a cloth moistened in cellulose thinners.

34 Pantograph machine engraving acrylic sheet.

Laminated plastics are available where the middle lamination is in a contrasting colour to the surface one. If such a material is used on a pantograph machine there is no need for the incised letters to be painted because the middle lamination will be shown up by the cutter.

Lettering on translucent or clear acrylic can be done on the opposite side from which it will be viewed, and the letters will show clearly through the acrylic. Where the acrylic has the quality of edge glow they appear to be illuminated in ordinary daylight conditions, so that work done on such material can be quite exciting and attractive. It must be remembered, however, that the letters must be engraved from a reverse image type so that they appear the correct way round to the viewer.

Where translucent or clear acrylics have not got edge glow cellulose

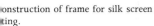

paint can be used in the same manner as described for the opaque acrylics.

Application: Door headings, information charts, signs of all kinds, presentation plaques.

Silk screening on acrylic

Silk screening has been a long and well established craft believed to have originated in Japan many centuries ago for producing prints on fabric and hard surfaces. In this day of modern technology it is as well established as ever in the field of commercial and industrial art. Nylon is now preferred for the screens because of its longer life and ability to withstand considerably more wear, and steel square section tube is preferred for the frames because of its ability to maintain constant dimensions and withstand the strains imposed by a taut screen. Wooden frames have the tendency to swell when washed in water and bend under the strain of taut screens, especially when the size of the screen is 6 to 10 ft. (2 to 3 m.) square. However, for the beginner working with much smaller screens, wood is an ideal material for the frame.

Constructing a frame

For a print 6 × 6 in. (150 × 150 mm.) it is necessary to make a frame about 14 in. (350 mm.) long by 12 in. (300 mm.) wide for the outside measurements. Soft wood is suitable but a hard one like beech will last longer and withstand the washing in water much more readily. Construct a frame from wood approximately 2 in. (50 mm.) wide by 1 in. (25 mm.) thick. Nail and glue the corners together. The glue must be water resistant.

Rub the glued frame down with glass paper to ensure that there are no rough edges likely to damage the gauze.

Cotton organdie is a common substitute for silk (and a little cheaper) while bolting silk, grade 8 xx, is of better quality and longer lasting. Terylene, grade 8 TT and nylon 85 NN, are two synthetic materials that are exceedingly strong and will last a long time providing they do not come into contact with anything hot.

Stretch the gauze as tautly and evenly as possible over the frame.

Cut the covering so that there is at least a 3 in. (75 mm.) overlap on each side of the frame. Pin the gauze at the centre of the two longer sides

37

with drawing pins. Work from the centre of each side pulling the gauze taut and pin on the outside edge of the frame. Keep the gauze completely flat avoiding ripples. Then glue the gauze to the frame and remove the pins.

Squeegee

A squeegee is essential for forcing the colour through the screen. This can be made from a piece of rubber $2 \times \frac{1}{4}$ in. (50×6 mm.) and $\frac{1}{2}$ in. (12 mm.) shorter than the inside width of the frame. The blade edge must be straight and tapered as illustrated. Attach a piece of wood to the back edge and make an overlap at the ends so that the squeegee can remain in the frame without getting covered with colour.

Squeegee

Masking the inside edges of the screen

This can be done with a varnish or adhesive paper or tape. A border of 2 in. (50 mm.) at the ends and 1 in. (25 mm.) along the sides is a minimum width for a masking border. The border provides a place to hold a reservoir of colour between each printing operation.

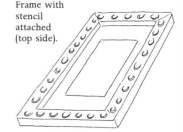

Frame with stencil attached (top side).

Making a stencil

There are numerous methods of making stencils but only one is described here in detail to demonstrate the principle of silk screen printing. Other methods can be readily obtained from books that deal solely with this subject.

Make a stencil with a thin, greaseproof paper, or with tracing paper. Draw a design directly onto the surface of the thin paper or trace it from a master design with a pencil. Shade the areas to be removed and then cut out the paper with a pair of scissors or a sharp knife.

The method of attaching the stencil to the screen is very simple. First place a trial piece of acrylic on the printing base and fix two register markers with an adhesive. Then place the stencil in exactly the position it is to print on the trial piece of acrylic. At this stage do not place any loose centre pieces of the design in position, as they will be attached later. Then lower the frame so that the gauze bears down on the stencil. Pour colour into the frame at one of the masked ends and 'pull' the colour over the screen with the squeegee. It will be found that the stencil will remain adhered to the gauze when the frame is lifted.

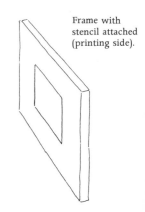

Frame with stencil attached (printing side).

Process

Place the loose centre pieces on the underside of the wet gauze in their intended position on the screen, lower the screen and pull the colour over the screen again. In this way, the loose centre pieces will be held in position by the colour on the under side of the gauze with the remainder of the stencil. Note that for each pull there must be a dry or clean surface on which to print.

When more than one colour is required in a design it is important that the successive prints 'line up', i.e. register, with the first print. This can

A. Frame B. Gauze C. Stencil D. Acrylic E. Register

36 Masking the frame.

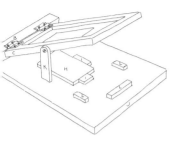

Setting the frame ready for printing.

be done by constructing a base (J) to which the frame is hinged so that when the frame is lowered it always returns to the same position in relationship to the base. Therefore, if the acrylic sheet fits snugly against two registers (I) the frame will always register with the acrylic. The registers must be the same thickness as the material upon which prints are to be made. A thicker material would eventually cause damage to the gauze as the squeegee pulls the colour each time a print is made.

Three blocks of wood (L) are also fixed to the base (J) to prevent movement of the frame when making a print.

The hinge (B) is a 'lift off butt hinge' which allows the frame to be easily detached for cleaning.

A strip of metal (K) is loosely held by a screw to the frame so that when the frame is lifted it swings down to support the frame in an elevated position and so enables a print to be removed and a new piece of material to be positioned for the next print.

Application: lamp shades, illuminated panels, advertising.

Silk screen printing and vacuum forming

Vacuum forming (see pp. 86–9) a thermoplastic material after a design has been printed on its surfaces produces some interesting distortions of the original design. The material stretches unevenly as it is pulled over the mould so that a straight line gets distorted after vacuum moulding.

An interesting project is to either do a silk screen print or paint a number of straight lines on a flat sheet of thermoplastic and vacuum form the sheet over a mould. Study the distortion of the lines carefully to see where the lines have stretched or shrunk and produce a design that will result in the finished product having straight lines. This is a practical problem for an artist designer who has to produce designs for vacuum moulded toys or relief designs. The face of an animal or doll has to look right in the finished item but the artist has to produce a distorted design that he knows will be pulled into correct proportion during the vacuum moulding process.

For the beginner, however, it is suggested that a grid of $\frac{1}{2}$ in. (12 mm.) squares be drawn on a number of sheets and each sheet vacuum formed over a variety of moulds. The resultant visual effects are fascinating.

Interesting panels can be made when a number of these moulded sheets are assembled side by side.

Engraving acrylic

General

A design must be drawn on a piece of paper, placed under a clear sheet of acrylic and on top of a back board, then clamped together. The surface of the acrylic may be engraved with wood engraving tools, or a dentist's burr in a flexible drive drill, or even by a piece of steel with a sharp edge sufficient to cut the polished surface. The frosted area produced by the engraving tool is similar in appearance to that produced by the glass engraver on glass, the advantages of engraving acrylic being that the

process is easier and can be done with quite ordinary tools. This makes it an ideal craft as a leisure activity.

If printing ink is rolled over the engraved surface and printing paper pressed evenly over it a print of the engraving can be produced. This process can be repeated over a hundred times without noticeable deterioration in the quality of line.

The process is, of course, very similar to those employed by the wood engraver and it should be remembered that the engraving is a 'negative' of the print: letters on the acrylic must be engraved so that they are round the correct way.

An engraved panel design

If the engraving is produced solely as an engraving, it is important to consider from which side of the acrylic the design will be viewed. Where transparent and translucent materials are used it is common practice to view the engraving from the same side as the unengraved surface, in which case the same rules for printing regarding the reverse image apply. Abstract designs are not so adversely affected and can be viewed from either side without serious distraction.

'Edge lighting' is a characteristic of transparent methyl methacrylate

38 Design engraved on acrylic.

sheet and can be used to advantage even if one only understands a little about the behaviour of light and the optical qualities of this material. Light received on one polished edge of acrylic sheet is transmitted by internal reflection to the opposite edge. If the light received strikes the surface at a greater angle than 42° (approximately) it is reflected back to the opposite side and the first side again until it has reached the opposite edge.

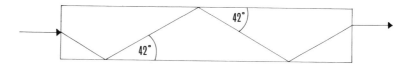

In the case of some acrylics the edges glow fluorescently and this edge glow is effective enough to be easily recognized.

If the polished surface is scratched some of the light is transmitted in such a way that it causes a glow similar to that seen from its edge. An incision in fact produces an edge which transmits light depending on the angle of the scratched surface to the polished surface. Depth of cut and distance away from the source of light also cause variations in the effect. A strip of acrylic with holes of increasing depth drilled at equal intervals along a line at right angles to the source of light can be used as a reference. A second line of holes may also be drilled at the same intervals as and parallel to the first line with holes, gradually increasing the depth the further away the holes are from the light source.

The unscratched surface remains unlit so that wonderful effects can be produced through the interplay of the unlit areas with the scratched formations.

Tubular lighting is the best artificial means of transmitting light to produce edge lighting in acrylic sheet. On a vertical plane the objects, figures, or designs can appear completely in suspension providing the polished surfaces are free from unwanted scratches. The light within the clear acrylic is apparent only at its edges and in the incisions made by the engraving tool.

Engraving

Because light must be transmitted from definite areas only, it is necessary to avoid even the smallest scratches on the polished surface. This can be done by using a flannel cloth to cover the edges where it is gripped by a frame or clamp; by using templates (plates in the desired design) to steady the engraving tool and to avoid the risk of the tool overrunning its mark, and, most important of all, by not removing the swarf with a dry cloth. Particles of acrylic and abrasive, if abrasive wheels are used, will scratch the surface and furthermore the rubbing of a dry cloth on acrylic material produces an electrostatic charge causing dust particles to cling to the surface. Either blow the swarf away, or use a wet cloth dampened with an antistatic fluid, wiping the surface lightly.

When engraving is done on the surface of a piece of acrylic it is an advantage to have a light source from one edge so that, as the engraving

progresses, the effects can be seen. A light frame can easily be made to (a) supply the light from one edge and (b) clamp the design on the paper and the acrylic sheet together so that they are secure while engraving is in progress.

1.

Problems of light intensity

It will soon be realized that to create similar intensities of light transmission the incisions have to be deeper the further they are from the light source—cuts of even depth show up more brightly nearer the light source. When the engraving is completed the edges of the sheet should be polished and, if light is to be kept within the acrylic, seal the edges with an aluminium foil or opaque white acrylic paint. The light will then be reflected back into the sheet and intensify transmission through the incisions of the engraving.

2.

Sand blasting

The breaking up of the highly polished surface with sand blown under pressure produces a frosted effect, which also transmits light similar to the incisions produced in engraving. This technique does require a rather specialized piece of equipment that is not normally found among the many tools and devices of an artist craftsman's workshop, and would therefore have to be done commercially.

The principle of the technique is extremely simple. The areas that are to remain highly polished must be protected and the areas to be frosted exposed to the stream of sand.

A similar effect to sand blasting can be obtained by cutting a stencil design in a piece of paper and pasting it onto the acrylic, remembering that the areas covered with paper will be the glossy surfaces in the finished design. Alternatively, shapes can be just cut out and arranged on the surface. The final stage is done with a hand spray. As well as a frosting spray (such as aerosol), colours can be used, and quite a variety of effects can be obtained this way. The paper is then removed and the finished design revealed. This technique is employed by artists to produce models of much larger work that are to be sand blasted, since it is comparatively inexpensive and gives the opportunity for experimentation.

3. Joi

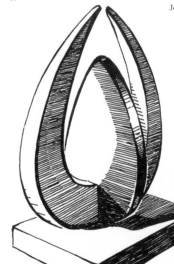

Carving acrylic

Edge glow is just as important in carving as in engraving. Where engraving is basically concerned with surface treatment, carving of sheet material is concerned with edge treatment. The edges produce different intensities according to their shape, so that specific effects may be achieved.

More and more sculptors are getting interested in acrylic as a medium. Leslie Summers who has been experimenting and developing his techniques with acrylic for some years has produced some very exciting work.

39 A simple design for an acrylic sculpture.

42

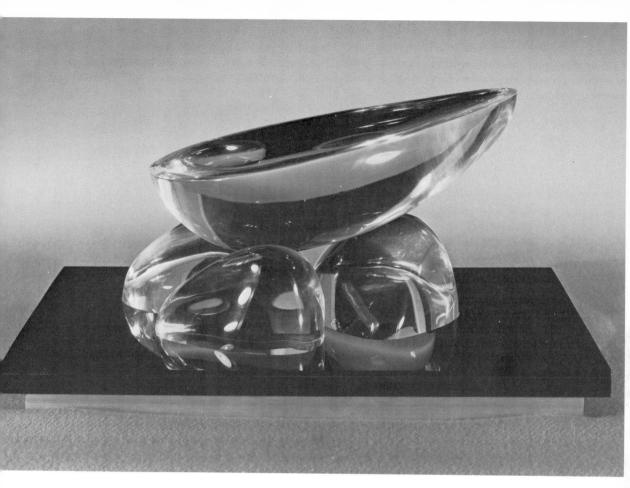

Suntrap: height 7 in. (178 mm.) in
~~rved perspex by Leslie Summers
~~hotograph courtesy of the Cork Street
~~llery, London).

The beginner can start by drawing a two-dimensional shape on the protective paper of the acrylic, using clean and sweeping lines. Not only does it make it easier to cut and polish the acrylic but the edge glow is much more pronounced. Cut the shape with a saw. Smooth the edges with a file or abrasive paper and finally with an acrylic polish. The finished shape may then be mounted on a base of similar material or, if desired, something quite different in character, such as wood or stone. The whole work then becomes an attractive and aesthetically acceptable piece of sculpture.

More adventurous work can then be tried involving several pieces of acrylic assembled to form a composition. The sheets can also be heated and made to follow gentle curves, thus creating a third dimension of some consequence.

The surface treatment of this type of sculpture can be developed but must be done when the acrylic is flat. Engraving or sand blasting can be carried out, and any other treatment will enhance the work.

The light source is quite an important feature of acrylic sculpture and it can make the difference between quite an ordinary looking piece of work and something outstanding. It can come from an overhead source or even from within the base of the sculpture. The latter method has been used with considerable effect by a number of sculptors, the bulb in most cases being completely concealed within a cavity in the base. Allowance

43

must be made for the heat generated by the bulb and enough air space allowed to prevent overheating.

Free form blowing

The simplest free form blowing known to man is blowing bubbles. The art of forming a thin film of a soapy solution across a ring made with the forefinger and thumb and causing it to stretch by blowing against the film is the principle applied in free form blowing of thermoplastics.

The acrylic has to be heated and held in a suitably designed jig before it can be blown. A design is illustrated in the photograph.

Oven

An electric domestic oven with a thermostatically controlled switch to keep the temperatures between 130 and 160°C (266 and 320°F) is suitable for most small work. A clamping jig and a car foot pump is required to hold the acrylic and to provide the pressure. Of the three items listed the clamping ring is the only piece of equipment that has to be made.

Clamping jig

This consists of two parts: a base plate and a profile ring. The base plate is designed such that it is possible to get a supply of air to its centre; it has a means of attaching the acrylic material and a profile ring to it. A simple way of clamping the three parts together is by bolting but quick release toggle clamps are preferred where a lot of free forming is to be blown.

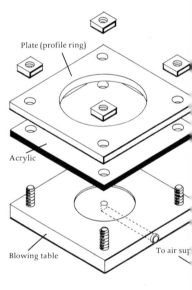

Plate (profile ring)

Acrylic

Blowing table
To air sup

Method

Cut the acrylic sheet to size and drill holes in the base plate and profile ring if they are to be bolted together (not necessary if toggle clamps are used). Bolt the plate and ring with the acrylic between together as tightly as possible to form a seal between the acrylic and the base plate. Then heat the whole in an oven until at a uniform temperature of 150 to 160°C (302 to 320°F). This may take ten minutes in a preheated oven for work approximately 3 or 4 in. (80 or 100 mm.) diameter, but twenty minutes or more for larger work. If the base plate is fitted with a good length of tube a portion of it can remain outside even when the oven door is still closed. The car foot pump or compressor can then be attached but it is necesary for a valve to be incorporated in the tube so that the air can flow in one direction only. Once air has been blown into the jig it is important to maintain the pressure in the hemisphere. Loss of pressure around the

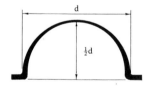

d

½d

41 How to assemble the acrylic in the clamping plates (*top*) and section through the blown hemisphere (*bottom*).

opposite
42 Clamping jig with blown acrylic sheet.

43 The hemisphere used as a food cover.

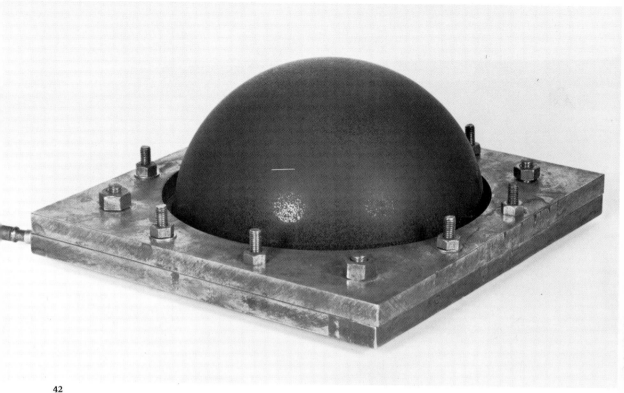

42
43

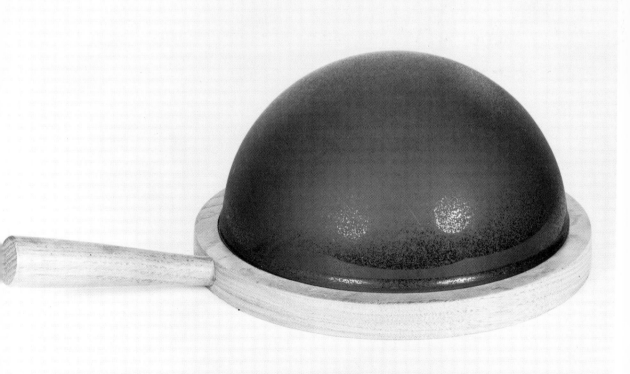

perimeter of the work or back down the tube will cause the hemisphere to return to its original flat form. It may be found necessary to tighten the nuts once the work has been heated, and while the acrylic is soft it is possible to compress the perimeter of the acrylic and produce a good seal.

Gradually pump air into the jig while it is still in the oven, whose door should be opened as little as possible to prevent cool air entering, until the acrylic is a true hemisphere, i.e. its height is approximately equal to its radius at the base, without fear of it bursting. Then quickly remove the hemisphere, still in the jig, from the oven, using asbestos gloves. (Delay may cause the hemisphere to overexpand, or even burst.) Do not touch the hot acrylic if marks are to be avoided, and allow it to cool in a draught-free place. When the work is quite cool, remove the acrylic from the jig, and trim and finish the edges as required.

Any thermoplastic material can be used in this way providing the correct temperatures are used. Care must be taken not to overheat it, for the surface can be either damaged, or made oversoft so that it bursts very easily. Also, uneven heating causes irregularities in the form of the hemisphere. Of course, if a lot of cool air is received on one side (as might happen when the oven door is opened), the hemisphere may be deformed with one flat side.

2 Polyester Resin

Encapsulation and embedment: general

Encapsulation, embedding, potting and setting are among the terms used to describe the same process, the art of encapsulating objects in a crystal-clear resin.

Long before sufficient knowledge had been acquired about polymerization (curing or hardening) of resins, the encapsulation of insects, leaves, and the like, occurred naturally many millions of years ago. Pine trees that grew in the lands round the Baltic Sea and are now extinct produced a thick sticky resin, which ran down the bark and branches of the tree, thus capturing in its path both insects walking on the bark and those that touched its sticky surface and were unable to free themselves. By a slow process, eventually the insects would become completely covered and encapsulated in the resin. The resin then hardened preserving the insect for many millions of years. We describe this hardened yellow, translucent resin as amber, and the objects that were encapsulated as being ambered.

Jewellery made from amber is extremely attractive, and if contained within it lies something preserved from the past, that makes it doubly interesting. The ship in a bottle never fails to create an interest and it is the same with ambered objects.

Today, by means of clear resins, activators and catalysts, encapsulation of objects can be completed within twenty-four hours under controlled conditions in a workshop.

Equipment

RESINS: We need a clear encapsulating resin. For maximum clarity use methyl methacrylate, but the slightly cheaper epoxy and polyester resins are only a little less clear.

HARDENER: the appropriate hardener (catalyst) must be used with the selected encapsulating resin.

ACTIVATOR: the function of the activator (or accelerator) is to control the time of curing: the more that is added, the shorter the curing time. However, a resin containing an activator only will not cure, or at least no notable change will take place for about a year, but a resin containing 2% activator and 2% catalyst can cure in minutes at room temperature of 18 to 21°C (65 to 70°F). Some resins are preactivated and do not therefore require any more.

CLEANSER: solvents of the resins are required for cleaning the equipment used but since they are, on the whole, highly volatile they should

44

45

be treated with care. They should only be used in a well-ventilated room and nowhere near a naked flame.

MIXING CONTAINERS: glass, metal, porcelain and polyethylene all make suitable containers for mixing the resin and catalyst in. Some plastics, particularly styrene, are not suitable for keeping a resin in for a length of time. If the resin is mixed and poured into the mould without much delay, all should be well, but if left to stand for a while the sides of the container will collapse and this creates an unpleasant mess. Wax cartons are also useful as mixing bowls and they have the advantage that they can be thrown away after use.

Warning: If too much resin is mixed in a wax carton it should be allowed to cure before throwing it into the bin where paper and other inflammable waste material might be thrown. During the hardening process heat is generated to the extent that a fire could be inadvertently started. If, on the other hand, the resin is well dispersed, the heat does not reach a dangerous level.

SPATULAS: metal, polyethylene, wood and glass spatulas are all suitable for stirring the resin. The important points to remember are, firstly, that the stirring implement should be clean and, secondly, that it is not affected by being in contact with an activated resin.

BALANCE: an ordinary domestic balance is useful for weighing resin, since it is necessary to know the quantity to establish the proportions of activator (if necessary) and catalyst.

THERMOMETER: the curing process depends very much upon the ambient temperature. In temperatures below 10°C (50°F) polymerization (curing) hardly takes place, but in temperatures of approximately 20°C (68°F) the resins cure at a comfortable rate. If the curing time is critical and must be known, it will be necessary to refer to a thermometer. However, as a simple guide, polymerization takes place at normal room temperature. If working conditions are very warm then the curing time is shortened; conversely, in cool conditions the time is lengthened.

MEASURING CYLINDERS: two measuring cylinders are necessary if activator and catalyst are to be used. (Safety type dispensers with built-in measuring devices are best. See section on safety under *Skin hazards*.) The two liquids should never be mixed or even poured into containers that at some time contained one or the other, because they react violently and could be explosive.

The tables referring to quantities of activator or catalyst are normally expressed in cubic centimetres (c.c.). Since the quantities are usually small a measuring cylinder from 0 to 10 c.c. is ideal.

Eye droppers are quite useful for measuring quantities below 1 c.c. The quantity is measured by counting the drops: 48 drops = 1 c.c., 24 drops = $\frac{1}{2}$ c.c., etc. Again separate eye-droppers must be used for activator and catalyst.

The work area

The craft of encapsulating does not entail having access to a special workshop since the equipment and materials are simple and light. Good

ventilation is important to disperse the slightly toxic fumes and to take away some of the smell inherent with this process.

Storage of materials

The resin should be stored in a cool place. The activator and catalyst should be stored in a dark cool place, *but not together*. The activator should be stored in one cupboard and the catalyst in another, since these two materials react with one another sufficiently to cause an explosion in a confined space. Also, the catalyst should be stored in a place not liable to combustion.

Work surface

The flat surface of a table or bench covered with a protective layer of newspaper or polyethylene is all that is required for a working surface. Spilt resin can easily be wiped off polyethylene or, if spilt on paper, thrown in the waste bin. Large spillages of activated resin should be allowed to cure before disposing in a bin, because the exothermic heat given off during polymerization is sufficient to cause combustion. Bulky quantities of catalysed and activated resin must never be poured straight into paper or cloth and thrown out. Rather, leave the resin in its container where it can do no harm and let it cure—the lump could prove to be most useful in a later design.

Measuring

Because the mould is often quite a different shape from the mixing container it is difficult to judge the quantity of resin required. To overcome this problem, pour water into the mould to the required level and then into the mixing container. Record the level of the water on the side. Pour the water away and dry both vessels properly before using them. Pour the resin, with activator and catalyst added, to the level indicated on the side of the mixing container. This process cannot be repeated for subsequent layers of resin because of the adverse effect the water will have on the resin already in the mould. So, quantities of resin for subsequent layers must be judged from the quantity required by the first layer.

The cubic capacity of a mould can be determined for simple shapes by multiplying the base area by the height or thickness. Such information is necessary to determine the weight of resin required. If the weight is known the quantities of activator and catalyst can be determined by referring to a table of recommended percentages.

To determine the weight of resin required, multiply the cubic capacity of the mould by the density of the resin (in the case of imperial measurements) or by the specific gravity of the resin (in the case of metric measurements).

E.g. length × breadth × thickness × density/specific gravity of the resin

(a) $\frac{1}{3} \times \frac{1}{6} \times \frac{1}{12}$ ft. × 64·8 (density)=0·30 lb. or 4·8 oz.

(b) 10 cm. × 5 cm. × 2·5 cm. × 1·1 (specific gravity)=737·5 grammes

To determine the correct amount of resin needed to produce a cylinder, multiply the volume of the cylinder (πr^2 by the height) by the density or specific gravity of the resin.

Simple aids for measuring approximate quantities of resin:

1 tea spoon holds approximately	5 g.
1 dessert spoon	12 g.
1 table spoon	25 g.

Measuring approximate quantities of catalyst and activator can be done with an eye dropper. To produce 1% catalyst or activator for 100 g. of resin, 8 drops from an eye dropper will give the approximate quantity.

Refer to the table for a wider range of quantities and percentages. (N.B. Do not re-use the eye-dropper for its proper function.)

The quantities of resin, activator and catalyst can be obtained reasonably accurately by using such ordinary household articles, but using an eye-dropper for the larger quantities of resin can get quite tedious. A mark on the side of the eye-dropper to indicate 10 drops, 20 drops, etc., is recommended.

Use two separate eye-droppers for catalyst and accelerator. Label the bottles and eye-droppers clearly so that the bottles and eye-droppers are never confused.

Percentage of Catalyst or Accelerator

Grammes of Resin	4%	3%	2%	1%	0·5%	
500	160	120	80	40	20	
400	128	96	64	32	16	
300	96	72	48	24	12	Figures are number
200	64	48	32	16	8	of drops.
100	32	24	16	8	4	
50	16	12	8	4	2	

Spoons

Grammes	Tea	Dessert	Table	
500	—	42	20	
400	—	34	16	
300	—	25·5	12	Number of spoonfuls.
200	40	17	8	
100	20	8·5	4	
50	10	4	2	

Curing

Generally speaking the higher the ambient temperature the quicker the resin cures, and the lower the temperature the slower. At temperatures below 5°C (41°F) the curing rate is almost at a standstill. Most resins are produced so that reasonable working curing rates occur between 18 to 21°C (65 to 70°F). While setting times can readily be established by timing known percentages of activator and catalyst mixed in a resin, the following guide may be useful: 1% of catalyst and 1% of activator take one hour (approx.) to set. 2% of each takes thirty minutes (approx.) to set.

46 Visual effects in tinted resin when viewed from different angles.

Colouring and tinting

Colour can be added to the resin before the catalyst and accelerator has been well dispersed. If a transparent or translucent quality is required only very small measures of pigment must be added to the resin. A spatula dipped approximately $\frac{1}{4}$ in. (6 mm.) into a pigment and the surplus allowed to drip off will leave sufficient to tint a resin. If the desired depth of colour is not achieved straight away more colour can be added before curing really begins.

It is not necessary for each layer of resin to be tinted to produce the effect of the entire block appearing tinted right through. A single colour layer at the bottom of an encapsulation will give the effect of the successive clear layers above also being coloured if the surface is inclined at 45° to the base layer (see diagram).

Coloured acrylic can be attached to the base of an encapsulation. If it is fixed with dowels or screws no colour will show in the block, but instead the base appears silvery. If, on the other hand, the coloured acrylic is cemented or cast onto the base the colour will show clearly.

Opaque qualities can be achieved by using opaque pigments. As much as 10% of colour by weight can be added to the resin to produce really deep, concentrated colours, but care should be taken to avoid adding too much pigment because this retards and, in some cases, inhibits curing. Blue and black are both known to slow down the curing process.

Moulds

A mould can be used to provide a shape to the finished piece of work or it can be used as a container from which the casting can be carved and polished to a desired shape later (see section on carving solid resin). The former method is quicker because it cuts out a lot of tedious polishing, but it does mean that the shape of the mould determines the shape of the casting.

There are many household items that make useful moulds, among them polyethylene ice cube moulds and food containers, or glass dishes. Moulds can also be made with sheet glass and battens of wood. Plain polyethylene sheet can also be used. The advantage of polyethylene are that the resin does not affect it so that a parting agent is not required, and its flexibility is of enormous help when trying to get the work out of the mould.

1. Pour first layer of resin

2. Cover mould

3. Place object in position

4. Pour second layer of resin and cover

5. Pour layer of tinted resin

...tages in encapsulating an object that ...not float.

Process

The first layer

Prepare a quantity of resin sufficient to form a layer approximately $\frac{3}{8}$ in. (10 mm.) thick in the mould, then carefully pour it in and allow to cure. The first layer of resin must be allowed to set hard enough to take the weight of the object to be embedded. If the object is likely to float, prepare a quantity of resin sufficient to cover only the lower half but allow the resin to cure because if the object is placed in the resin still in a liquid state surface tension will attract it to the sides of the mould.

During setting the mould should be covered with a piece of paper or card to keep dust off. Even when the resin has set the cover should remain until the object is ready for encapsulating, because any dust allowed to fall on the tacky surface cannot be removed and a cloudy layer will show up in the final piece of work.

If the resin is allowed to cure in the mould the top surface will remain tacky (a few clear resins produce a non-tacky surface and in such cases the following procedure is not essential), so that the sides against the surface of the mould will be quite dry, while the surface is not. This is because air partially inhibits the curing process, and only if air is excluded from the top surface can complete polymerization take place and a smooth, non-tacky surface result. This is achieved by placing a piece of cellophane on the resin before it has begun to gel. When the casting has had time to cure the cellophane can be removed. A smooth, flat, dry surface will be revealed and many minutes of cleaning and polishing prevented, for a tacky surface has to be cleaned with a solvent or scraped with a knife and spatula, rubbed down with glasspaper and fine carbide paper, and finally polished.

When applying the cellophane to the surface of the resin it must be slid on from one side so that air is not trapped in the resin and if glass can be placed on top of the cellophane this will ensure not only a non-tacky surface but also a completely even one. The cellophane and glass should be removed as soon as the resin has cured. If allowed to remain the cellophane will crinkle and produce marks on the resin. The flat non-tacky surface can be polished to give it a real lustre. Any defects, however, must be removed with fine abrasive papers before polishing.

The next layers

The ideal time to pour the next layer is as soon as the previous layer has set, which can best be judged by gently squeezing the outside of the mould, if the mould is flexible, e.g. made of polyethylene. A rigid mould can be gently tilted to see whether there is any movement. Of course, if the resin, catalyst and activator are carefully measured, i.e. using a balance for the resin and separate measuring cylinders for the catalyst and activator and collating the amounts with a chart for a given temperature, then the curing time can be determined accurately.

If the resin is allowed to remain standing for a long period, e.g. two days, the curing action still continues, though at a much reduced rate, and consequently the resin contracts in size. A space between the mould

and the resin is created and when the next quantity of resin is poured some will trickle down the space. No harm is done but time will have to be spent rubbing down and polishing the sides. This feature is particularly noticeable when a coloured layer of resin is poured over a clear resin, since the runs of colour reveal the spaces very readily.

Place the object centrally, or in whatever position is desired, on the first layer and pour the prepared resin carefully and slowly round the object. When it is only partially covered in resin, allow the second layer to cure. Finally, prepare sufficient resin to cover the object completely with a layer no more than $\frac{3}{8}$ in. (10 mm.) thick. If the object is not completely buried even then, prepare sufficient resin to produce layers $\frac{3}{8}$ in. thick until the object is encapsulated.

Occasionally, it is advantageous to pour quantities of resin to form a layer thicker than $\frac{3}{8}$ in. (10 mm.). This can be done if the curing resin is kept cool, for during this stage considerable heat is generated by the chemical reaction known as polymerization. If the resin is allowed to get too hot crazing takes place. The appearance can be extremely attractive in a resin that has been tinted with a translucent pigment but terribly annoying if maximum clarity is the objective, as tends to be the case with encapsulation. So, a mould containing a quantity of resin likely to generate sufficient heat to cause crazing must be kept cool (room temperature) by placing it in a water bath. Obviously water must not come into direct contact with the resin so this operation also must be done with a certain amount of care.

Removing the casting

If the mould has plenty of draft and its walls polished with a non-silicone wax there should be no problem in removing the casting. In fact it may be that the casting is quite free from the sides due to the resin's high rate of shrinkage. Polyester resins lose about 3 to 5 per cent of their volume during setting.

However, sometimes an awkward casting sticks to the sides of the mould and resists attempts to tap it or shake it out of the mould. Levering with a knife or screwdriver will only damage the casting and should not be attempted. Instead dip the mould and casting in hot water, allowing sufficient time for the casting to become thoroughly heated, then allow it to cool. The resin expands and contracts six to eight times as much as glass or metal, and because of this a separation between casting and mould is inevitable. Warning: boiling water causes crazing, so only use it if that effect is intended.

Stresses

Because of the considerable difference in the rates of expansion between resin and metal or resin and glass, when these two materials are combined in a piece of work, stresses occur between the two materials during polymerization, which can continue for months even in the case of some resins. However, if the process is hastened by warming the casting in an oven at a temperature between 60 and 80°C (140 and 176°F), this relieves stresses and there is no reason for separation between resin and the embedded object to take place. However it is only to be recommended

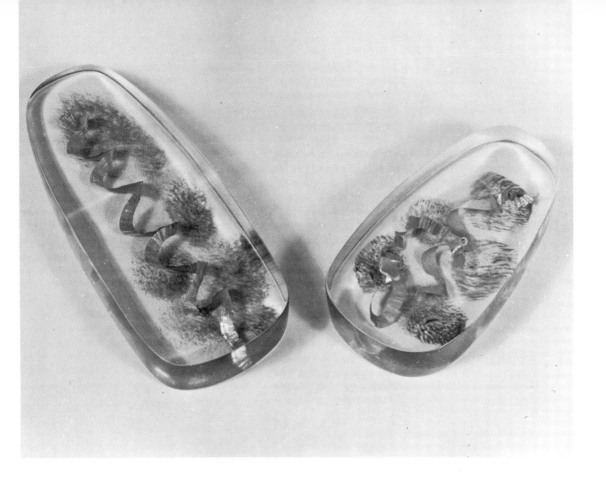

48 Metal swarf plus five drops of pigment dropped in the resin and allowed to disperse naturally. (Made from moulds described on pp. 88–9.)

after the 'green stage' has been reached, i.e. when the resin is firm but slightly pliable. This hastening process by an elevated temperature is sometimes known as 'tempering'.

Preparation of objects

A large variety of objects can be encapsulated in resin, including mineral samples, metallic objects, wood, paper, cloth, plants, dead insects, birds' eggs, sea shells, fossils. Dried plants are more easily encapsulated than freshly cut plants, for the moisture within fresh plants inhibits the process and imparts a haze to the resin. Further, if the leaf or flower is to preserve its colour, it must undergo a process which is explained in detail later. Metal, stone or dry zoological specimens need little or no treatment before embedding in resin. Metals should be clean, free from oil and traces of grease. Also, ferrous metals do tend to oxidize during embedding if the surface is not protected with a lacquer, for which a coating of clear polyurethane is recommended. Copper acts as an inhibitor and causes resin to go slightly pink; again, a coating of clear polyurethane is recommended. Aluminium, brass and other common metals and alloys have no effect upon the resin and need no special treatment before embedding.

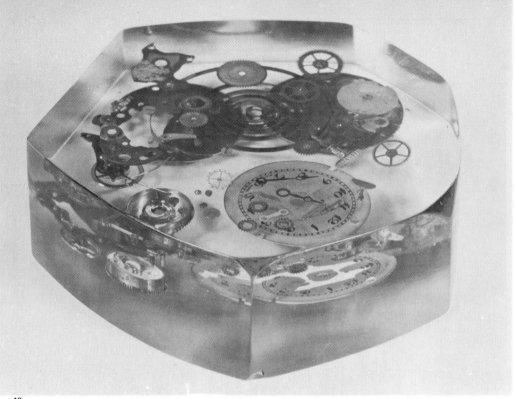

49

50

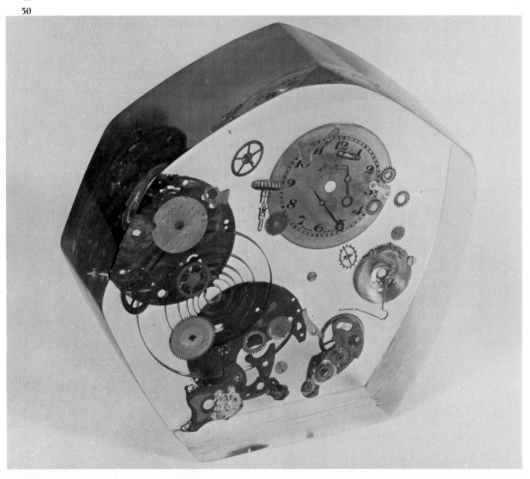

In the case of stone, provided that the specimen is clean, there is really very little that needs to be done. A little care is needed, however, with porous stones. The air needs to be extracted so that the embedment is not surrounded by trapped air bubbles in the final piece of work. This can be done by pouring in a number of layers of resin, letting each one set before pouring the next. The air is forced to rise to the top of the stone and when the final layer of resin is poured to completely immerse the stone, what little air is left can rise to the surface and escape.

Coins

Select a mould that will provide the final shape, e.g. a shallow hemispherical glass dish. Polish the inner surface of the mould thoroughly with a non-silicone wax polish, then spray or sponge it with a cellulose lacquer. When the surface is absolutely dry prepare a quantity of resin by adding 2% activator. A vigorous action introduces air bubbles into the mix and these have to be released before the curing process gets too far under way. Some bubbles of air rise to the surface during the curing process when the resin becomes quite warm. Cover the mould to prevent dust particles landing on the surface of the resin and allow to cure.

Prepare a second quantity of resin in the same way as before. Dip the coin into the resin while it is still in the mixing bowl, as this wets the surface and lessens the chances of trapping air when laying it on the surface of the now cured first layer of resin. With the coin carefully placed in position pour the resin over the coin so that it is completely encapsulated.

Coins set in clear resin.

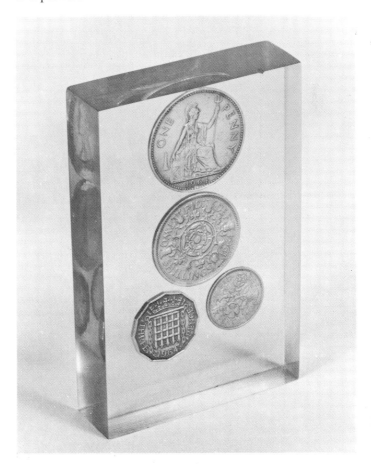

It should be noted that, because copper inhibits the curing process, coins containing copper should first be coated with cellulose acetate or polyvinyl alcohol before encapsulation.

With the second layer cured the casting can either be removed from the mould or a third and final layer of resin added. To give the encapsulation a further attraction add colour to this layer to present the coin on a coloured background. This layer will be the underside of the paper weight and will not in any way obscure the coin unless of course an opaque pigment is used. Translucent pigments used sparingly produce the most attractive results and do not completely obscure the view of the coin from the underside.

If this third coloured layer is desired it should be done as soon as the previous layer has cured, because the resin contracts considerably after curing—it pulls away from the mould, leaving gaps for the coloured resin to run into and so causing unnecessary runs of colour where it is not wanted.

After the last layer has been poured into the mould cover the exposed surface with a sheet of cellophane so that air is completely eliminated. Air inhibits curing and any resin surfaces exposed to it remain tacky even though the rest of the casting has cured completely.

Releasing the casting from the mould can be quite a straightforward action if the mould was polished properly at the beginning of the process. Should there be some difficulty however gentle warming and cooling in water usually does the trick. Resin has far higher rates of expansion and contraction than glass and separation during the heating and cooling stage takes place very quickly.

Plants and leaves

Dried specimens do not need quite as much preparation as freshly cut leaves and flowers, which contain a high proportion of moisture and, when embedded in this condition, are liable to wither after a short while. Also the chemical reaction which takes place during the curing of the resin causes some deterioration of the colour.

A preservation fluid for botanical specimens is available from suppliers of embedding materials and should be used according to the suppliers' instructions. In general, the freshly cut plant specimen is immersed in the preserving fluid. (These fluids contain a certain amount of undissolved solid material which gradually disappears as the fluid is used.) The specimens become brittle after being in the preservative and care should be taken when handling them. Excess preservative must be washed away in running tap water and excess water removed by blotting off and exposing the specimen to dry air until the outside is dry. Assisted drying by hot air is only liable to distort the specimen and cause the rich green colour to fade and change as it would at lower temperatures over a longer period. The curing process of the resin during embedding is also liable to cause the green leaf to brown in patches. This can be prevented by immersing the freshly cut specimen in a colour preservative for one or two days. Again, the excess preservative is washed away in running tap water and the specimen dried before embedding. Some green leaves become translucent, others remain opaque. Also any bruising which may

not be obvious before embedding shows up quite distinctly when embedded.

Because of the wide variety of plants it is not possible to make a comprehensive list of the effects that take place for every type of plant. As a guide the evergreen leaves such as ivy and holly remain opaque, but green leaves from the deciduous plants generally become translucent. Dried leaves that have lost their green colouring and are a shade of brown retain their opaque quality.

Flowers

Again the enormous variety of flowers available for embedding make it impossible to produce a comprehensive list of the effects that are likely to occur. The beginner is best advised to try sample flowers and to see the effects of embedding before proceeding with a final piece of work.

Flowers are quite complex structures made up of several parts which tend to become detached when handled, e.g. the petals from the calyx, particularly after the flower has been immersed in a preserving fluid. If, however, the flower is coated with a clear lacquer this does help to keep them together. The excess preserving fluid should be removed in running tap water and then completely dried before the lacquer is applied.

Provided that the flower is well protected from any damage or moist conditions it can be kept for a considerable time before encapsulation. A convenient method of storing is to place the flower in a polyethylene

ʰulip tree leaf (*left*) and ivy leaf (*right*) ıpsulated in clear resin.

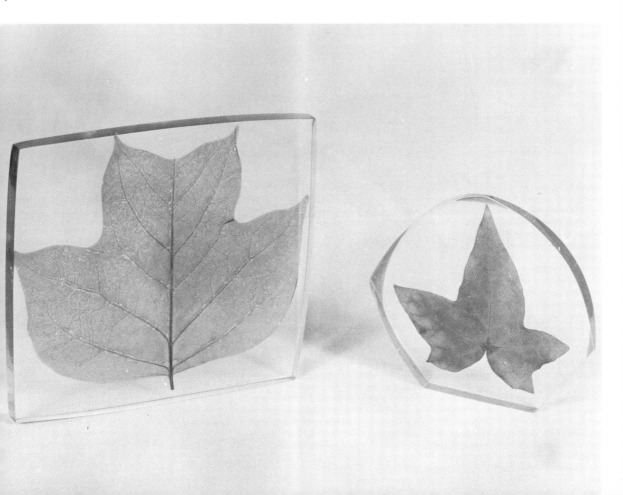

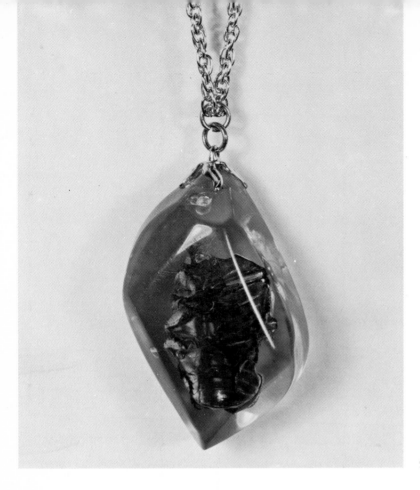

53 Pendant with encapsulated scarab.

bag containing a small quantity of a desiccant, then placing the bag and its contents in a substantial container to prevent the flower being accidentally crushed.

Pendants with encapsulated objects

The mould can be based upon a natural shape obtained from a pebble or a formal shape obtained from a piece of plywood cut to a desired shape.

Choose the pebble for its smooth surface and clean line, then place it in a tray and submerge it to half its thickness in plaster. Next, carefully remove it, leaving a clean hollow impression. Seal the surface with a lacquer and polish it with wax or a suitable release agent. When doing this type of embedding it is advisable to make a number of impressions from a variety of carefully selected shapes.

Prepare encapsulating resin and pour a quantity into each mould. Place the objects for encapsulation in position and prepare a second quantity of resin. In the third and final layer of resin a colouring pigment can be added to act as a background to the objects encapsulated. Place a sheet of cellophane over each mould so that the final surface cures thoroughly and a non-tacky surface is produced. Alternatively, place a

54 Resin cast from a wood sculpture by Maurice Jadot using the flexible mould technique (photograph courtesy of Maurice Jadot).

60

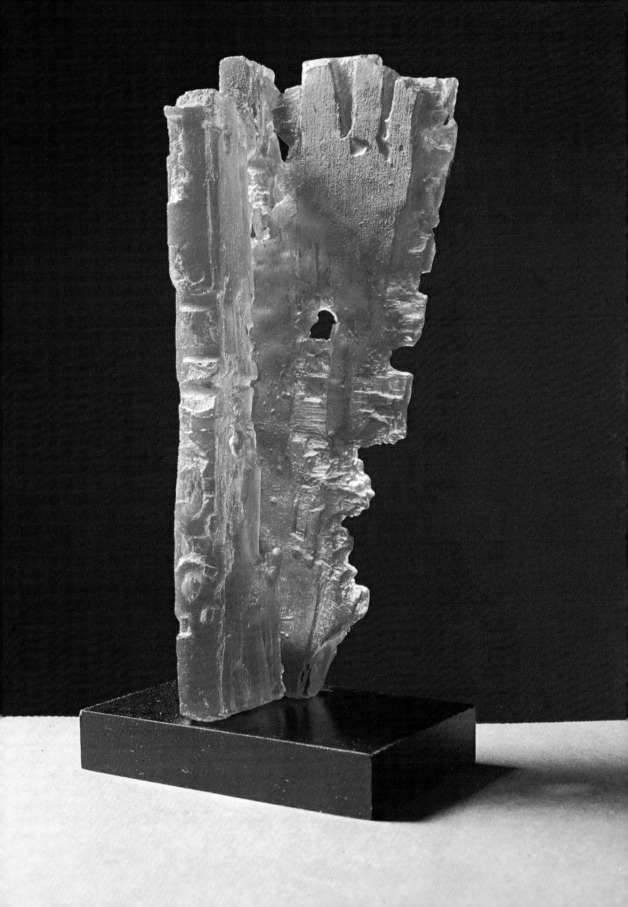

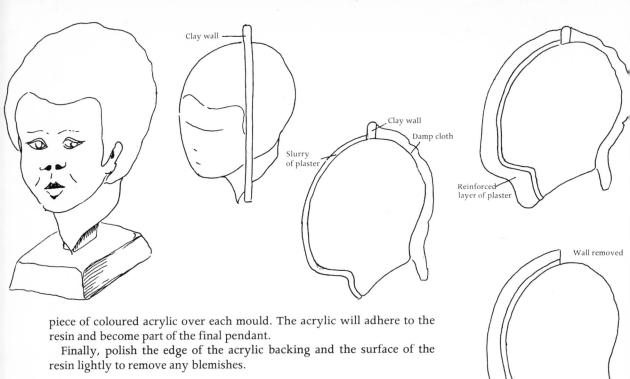

Clay wall

Clay wall

Damp cloth

Slurry
of plaster

Reinforced
layer of plaster

Wall removed

piece of coloured acrylic over each mould. The acrylic will adhere to the
resin and become part of the final pendant.

Finally, polish the edge of the acrylic backing and the surface of the
resin lightly to remove any blemishes.

Casting resin

This process is sometimes referred to as cold casting since no heat is
required. Polyester resin comes in a liquid state and only requires the
addition of a catalyst and an activator to change it to a solid one.

Before a casting can be made it is necessary to have an original piece of
work, such as a piece of clay abstract sculpture, that can be used as a
pattern to provide a mould.

First cover one half of the clay sculpture with a thin slurry (coating) of
plaster of Paris to avoid trapping any air; a damp cloth prevents the
other half being covered. (In the case of most three-dimensional work a
split mould is essential if the pattern is to be removed; with simple shapes
it may be only necessary for the mould to be split into two parts but for
more complicated work it may have to be split into more than two.)
Then apply a thicker mix of plaster to an approximate thickness of
$1\frac{1}{2}$ in. (37 mm.). During the plastering process strips of cloth soaked in
plaster can be added to act as reinforcements. Select the boundary of
each part of the mould to provide the minimum of obtrusiveness of
mould line on the finished work and easy withdrawal from both the
pattern in the first instance and the final casting at a later stage. Each
boundary is provided with a clay wall approximately $1\frac{1}{2}$ in. (37 mm.)
high.

When the plaster has set, remove the boundary wall so that the clean
edge of plaster is revealed. Then paint the exposed edge with a watery
clay solution or slip, which prevents the adjoining area of plaster mould-
ing itself to the first or previous layer and also assists in the removal of
each part of the mould.

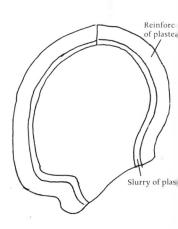

Reinforc
of plaste

Slurry of plas

55 Making a plaster mould from which
to cast resin.

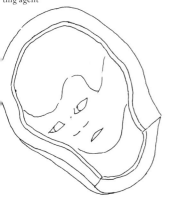

Carefully lever apart the mould by gentle tapping and by working a chisel backwards and forwards in the parting line until finally the moulded parts come completely away from the clay original. Any clay remaining attached to the mould must be washed away while it is still soft and the mould left for at least twelve hours to dry out.

The inner surface of the plaster mould is coated with sealer and a release agent, and may require a second treatment if the plaster is particularly absorbent. A coating of wax polish will also assist the casting to part from the mould.

Hollow casting

Paint the mould parts with a gel coat of polyester resin that has had a filler added to it, either a colouring pigment or a metallic powder such as copper, aluminium, brass, lead or zinc (ferrous metals are not recommended because of oxidation). Also, of course, the resin must be activated and catalysed to ensure that curing (hardening) takes place. Add a layer of glass fibre and resin to give strength to the casting, for resin on its own is quite brittle. There is no need for more colouring or metallic powders to be added, the function of this layer being purely to reinforce the casting.

When the parts of the mould are assembled after the resin has cured and are held together by bands of wire, apply a final layer of glass fibre and resin to the joints. This time pigment or metal powder can be added to ensure that the parting line is completely concealed.

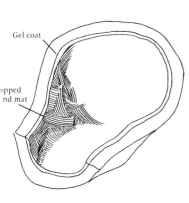

Gel coat

pped
nd mat

Removing the plaster

If there are no undercuts on the clay original the plaster should come away cleanly after soaking in hot water, but where there are difficult spots the plaster has to be chipped away with a knife or chisel.

Should there be any blemishes on the casting these can be easily repaired at this stage. If particular care has to be taken in matching colours it is helpful to have some uncured resin left over from the gel coat used earlier. If a small amount of gel coat has had colouring added, but no catalyst, it can be put into a small container until the repair stage is reached. Catalyst is added just prior to use.

When the repaired areas have cured they will appear a different colour from the rest of the casting though made from the same batch of coloured gel coat resin, because the cured resin was in contact with air. This may be remedied by gently rubbing with a scouring powder on a damp cloth which will soon bring the repaired area to the same colour as the rest of the casting.

Modelling with resin

Possibly the first material that most amateur and professional sculptors have ever worked in was clay. It is soft, malleable, and has an adhesive quality that allows more clay to be added. The final stage for any clay

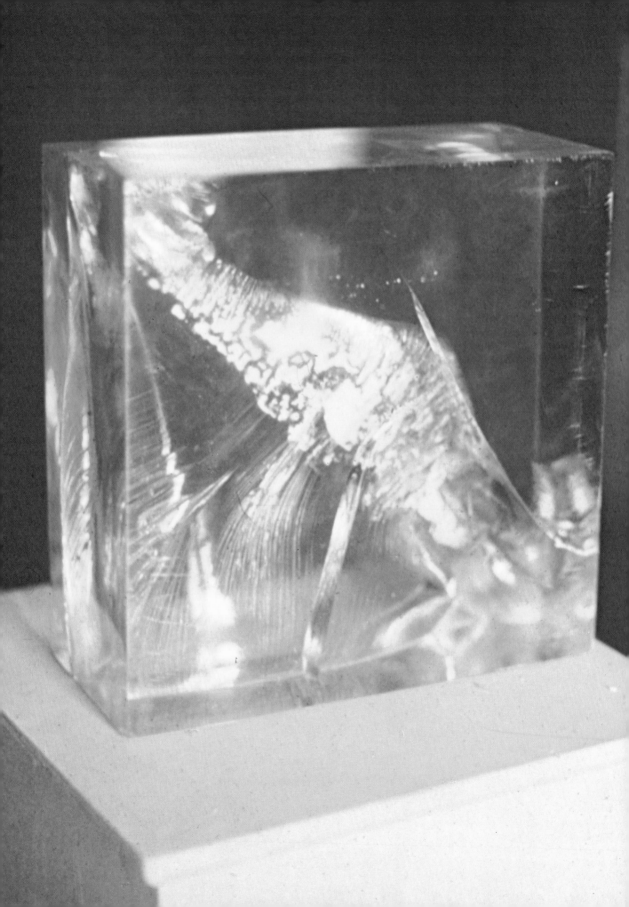

ast polyester resin and acrylic sheet
amela Brown Dip. A.D. (Sculpture)
.

sculpture however is firing in a kiln so that unless there is an opportunity for firing there is little point in sculpting with clay if a lasting piece of work is to be made. On the other hand, this need not be a problem for the sculptor using resin. Resin sets hard when a quantity of catalyst and activator is added, and it will have the lasting quality similar to fired clay sculptures.

Design

To start a piece of sculpture it is necessary to have an idea of the form and size, remembering that if it is to be free-standing it must be able to support itself. Polyester reinforced with glass fibre is very light material and weights may need to be incorporated in the design of the base.

Making a resin model.

The frame

Most sculpture is built up on a frame or armature so that the flexible modelling material is given rigidity while it is being worked. It can be made from wooden battens or metal rods, metal being more suitable for long slender forms. If metal is used it is often necessary to weld the pieces where they meet to give maximum strength, or, if welding equipment is not available, the pieces of metal can be held together by twisting soft wire round the joints. They can then be further strengthened by binding glass fibre tape soaked in a catalysed resin round the joints and allowed to set. The mild steel rods should be painted with an anti-rust solution before coming into contact with resin. Where there are broad shapes the main mass can be built up with wire mesh.

Stiff wire or metal rod

Staple

Covering the frame

The framework is now covered with glass fibre mat, the cut-out shapes of which are attached to the framework with catalysed resin. Small bits can be saturated with resin and tamped into place with a stiff-haired paint brush, while large areas of mat can be attached at various points. When the resin has set, to hold the mat in place add more resin.

Hessian

Glass fibre

First layer of resin

Fine wire

Wire netting

w or nail

Paper rope

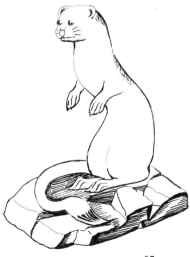

Modelling

Now the framework is completely covered with a layer of glass-reinforced resin it is ready for the actual modelling process.

A polyester resin with an inert filler such as kaolin or slate powder is prepared and modelled onto the framework with a spatula, as the resin in this pasty condition retains its shape from the spatula. If the resin sags under its own weight then more filler is required. Glass wool, as used for insulating lofts, makes a good filler and gives the resin sufficient body to make it workable.

Colouring

The work should now be ready for a pigmented or metal-powdered resin to be applied as the top and final layer. If the sculpture is to take upon a metallic appearance various metal powders can be added to the resin. Copper and aluminium are sold in powdered form for this purpose but others can be obtained from workshops. Experimentation with additions of this kind can lead to novel achievements.

Sculpture finished in this way will have a metallic appearance, if metal powders are used, but with a modelled surface texture. Those initiated only in the use of clay or metal may find the finished work unacceptable but at least it is an honest use of materials and far better than the simulation of traditional ones.

Plastics have an identity of their own and there should be no feeling of guilt that items made from plastics obviously look plastic. Too many items, particularly in the commercial world, are made from plastics masquerading as a traditional material. Further, not content with this, manufacturers also imitate the process by which it was produced, e.g. plastic sheets of what appears to be beaten copper.

Admittedly, one of the qualities of plastics is their adaptability to give the visual appearance of another material, so that it is not until it is touched or lifted that its true identity is realised. The use of plastics in the restoration of old stone buildings is justifiable on the grounds that it achieves the visual appearance of stone easily and is weather-resistant.

So, for those wishing to copy examples of work made in metal, stone or clay, plastics is an ideal material, while for those who wish to use plastics imaginatively and creatively, there is an immense opportunity for experimentation.

Carving resin

Cured polyester resin can be carved with such tools as surforms, coarse files, abrasive discs and wheels.

If a bulky carving is required without crazing, very little catalyst and accelerator are required, i.e. less than 1% of each. The curing process may take several weeks but very little exothermic heat will be generated and stresses that result from a rise in temperature will be avoided. However, if stresses do produce fissures, the surfaces reflect from within the resin, which can be extremely attractive and become the focus of interest in a piece of carving.

Fissures or crazing effect

During the mixing stage add between 4% and 6% catalyst and accelerator to the resin. To give a further interest add a small dash of translucent pigment to the mix, which is then poured into a mould and allowed to cure (see below). Quite high temperatures can occur with this process. The mould becomes too hot to hold and when wax cartons have been used the wax will melt and drain away from the card. It is advisable, therefore, to keep the mould where it can do little harm. The stresses set up in the curing will produce fissures.

Once the resin has cured remove it from the mould and cut it with whatever tools are available. Then smooth the carved block with abrasive papers and finally polish it until a highly glossy surface is produced. This process can be tedious and lengthy if a high standard of finish is required. An alternative finish can be achieved more quickly by coating the carved resin with a highly catalysed and accelerated resin. If applied carefully with a brush there should be no need for further treatment.

Trailing colours

Pigments have a tendency to disperse and to sink. If a quantity of coloured pigment is trailed through some freshly catalysed and activated resin the pigment will tend to find its way to the bottom of the resin. To avoid this the process should be divided into a number of stages.

1. A small quantity of clear resin is prepared so that a layer approximately $\frac{1}{4}$ in. (6 mm.) thick may cure in the bottom of the mould.
2. A second quantity of clear resin is prepared, sufficient to produce a layer $\frac{1}{8}$ in. (3 mm.) thick. While the resin is still liquid a trail of colour is added by dipping a glass rod or stick first into the container and swirling it around in the uncured resin. Only a small quantity of colour and a limited number of swirls is required, as overdoing either part will merely result in an even distribution of pigment. Remember that colour dispersion continues after the final movement with the rod—it is necessary to try to assess the point when no more swirling is required to produce the desired effect in the finished article.
3. A final layer of resin can be poured when the previous layer has cured sufficiently for no more movement of the pigment to take place.

In a more complex design several layers are built up so that trailing colours are superimposed one upon the other. Colours are also added as droplets to form areas of colours in the design.

Resin sculpture

Maurice Jadot has made some interesting resin sculptures cast from forms in traditional materials. Stone dust, obtained from a local monumental mason, as a filler in the resin gives it the appearance of stone. Similarly metallic powders added to the resin give the appearance of metal sculp-

ture. Sometimes he makes no attempt to simulate traditional materials and allows the qualities of the resin to be sufficiently satisfying in themselves. A mould will always give the same shape but various colour effects and textures may be achieved.

Panelling

There are a number of ways in which to make wall panels or screens.

Panels from a flexible mould

58 Cloth impregnated with polyester resin placed between two sheets of glass treated with a release agent.

A design is first of all produced in a slab of clay approximately 1 ft. (300 mm.) square by 1 in. (25 mm.) thick, modelling being carried out with a spatula or any instrument that will produce the desired finish. Objects can be pressed into the surface and repeated many times. Some impressions can overlap each other to produce effects inherent in the overlapping. The surface texture can be left smooth or rendered rough by scratching or piercing with a pointed instrument. A coarse piece of cloth or netting can be pressed into the surface. In fact, almost anything can be used to leave an impression.

Next, surround the clay panel by a frame made from wooden battens. The length of the sides should have an inside measurement approximately 2 in. (50 mm.) larger than the sides of the panel so that a space of approximately 1 in. (25 mm.) is left between the clay panel and the frame. The wooden battens should also be approximately 1 in. wider than the thickness of the clay panel. Place the frame concentrically round the clay panel and attach it to a base board with wire nails.

Pour a flexible mould material over the clay panel until it reaches the height of the wall. (See section on moulds, p. 52.) Allow the material to gel before removing the clay panel from the mould.

With the flexible mould inverted so that the hollow side is uppermost paint a prepared gel coat (catalysed and pigmented) on the surface of the mould. Make sure that the mould rests on a flat surface otherwise any undulations under it will be reproduced in the final panel. Cut a sheet of glass fibre the same size as the mould not forgetting to allow for the vertical edges at the sides. Prepare some general purpose resin when the gel coat has hardened and paint a second layer; colouring is not required. Place the glass fibre in the mould and stipple with a stiff-haired paint brush until the glass fibre mat has become soaked by the resin and taken up the contours of the panel. Allow the resin to cure, trim the edges with a strong pair of scissors and remove the panel from the mould. With care the mould can be used to make a number of panels.

Suspended lumps of colour

Suspend cured lumps of opaque or translucent coloured resin on colourless nylon thread in a translucent resin, the loose end of the thread being attached to a stick or pencil resting on the rim of the mould. Once the resin has cured trim the ends of nylon, remove the resin from the mould and carve it. The carved surfaces produce prismatic distortions of the suspended lumps of resin when the surface is highly polished.

68

Tissue mat

Resin

Waxed glass

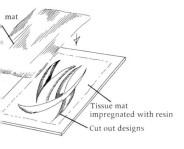

mat

Tissue mat
impregnated with resin

Cut out designs

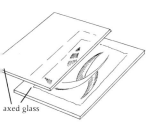

axed glass

Making a panel using cut out shapes
cloth or paper to form the design
re.

Resin panels with lumps of colour

Arrange coloured shapes of precast polyester resin on a resin-covered panel, but keep the shapes apart so that a thixotropic resin can be poured into the spaces. A polyethylene squeezy bottle with a tapered nozzle makes an ideal dispenser. Care should be taken to avoid spilling the resin over the precast shapes, but should this happen the resin can be wiped off with a piece of cloth soaked in acetone (avoid moving the shapes). Using this technique many interesting panels can be made by having the shapes in translucent colours and the grouting resin opaque.

Panels with cloth

Pour flexible polyester resin on a smooth sheet of polyethylene. Place a piece of cloth in the resin. Cover with another sheet of polyethylene, press the air bubbles out and evenly distribute the resin. To produce flat surfaces squeeze the resin-impregnated cloth between two pieces of plate glass.

Translucent panels

Pour catalysed resin over wax-polished glass. Cut a sheet of tissue mat glass fibre just larger than the size of the panel and place it in the resin. Lay paper cutout designs on the impregnated glass fibre and pour more resin over the panel. Place a second layer of tissue mat over the design and stipple the work to bring the resin through to the surface. If a smooth glass-like surface is required to both sides of the panel place a second piece of wax-polished glass over the still wet surface of the panel. When the resin has had time to cure carefully remove the glass and trim the panel with a strong pair of scissors.

Panels from a wax-carved surface

A tray is made from four battens screwed to a flat piece of plywood $\frac{1}{2}$ to $\frac{3}{4}$ in. (12 to 18 mm.) thick. Molten wax—paraffin wax is best—is poured into the tray to a depth of approximately $\frac{3}{4}$ in. (18 mm.), but if considerable relief is required a deeper layer must be poured. As soon as the wax has hardened carving with simple hand-made implements can begin, but remember that the carving will produce a negative of the finished panel. Undercutting the wax should be avoided unless it is done with intent to emphasize the relief.

Catalysed resin is poured onto the carved surface. Since this will be the visible layer of resin in the finished panel special textures and colouring pigments can be added to it (subsequent layers can be pigmented only for translucent effects). Mix the quantity of resin according to the desired thickness of panel. If percentages of activator above 4% are used the curing process will not only be quite rapid (ten to fifteen minutes at 18°C or 65°F) but the exothermic temperature will go above the melting-point of the wax and cause it to soften at least, if not to melt. Softening of the outlines can be attractive, but it completely smooths out very fine detail. Therefore, in the latter case, low percentages of activator and thin layers of resin are recommended so that exothermic temperatures

remain below the melting-point of the wax. On bold carving the softening of outline may be desirable in which case higher percentages of activator can be used.

When the resin has cured one of the sides of the mould can be removed and the panel prised up from the wax.

60 Wax carved and set in a frame ready to receive a layer of resin.

Panels from wax-polished glass

A catalysed polyester resin poured onto a wax-polished surface of glass and allowed to cure is the simplest method of producing a panel, the resin being contained within a wall of clay, putty, plasticine, etc., to any desired shape or dimension. Press the chosen material firmly onto the wax-polished glass to ensure that the resin does not escape. Pour the mixed resin into the enclosure and allow to cure; the thickness of the resin should not be more than $\frac{3}{8}$ in. (10 mm.). If a very flat surface is required on both surfaces the resin must be in contact with wax-coated glass on both sides of the panel which can be done by placing a second piece of treated glass on to the resin. However, the walls keeping the resin in must be the same thickness as the intended panel. The resin must fill the area completely and the glass slid into position without trapping any air. Place a weight on top to keep the glass in place.

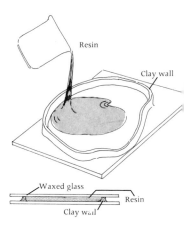

Another way of carrying out the same process is to place a piece of vinyl strip between two pieces of treated glass, keeping them together with strong filing clips. The vinyl provides a seal for three sides only, the fourth side being left open so that the resin may be poured into the space between the two pieces of glass. Pour the mixed resin carefully onto a glass rod with one end in the opening so that, by surface tension, it flows between the pieces of glass at a controlled rate. Trying to pour resin directly into such a narrow opening often results in spillage.

Aluminium angle makes ideal edging strips for panel making. Four lengths can be used to provide panels of varying sizes and proportions by using the method shown. The angle is held in position by clips and a seal between the angle and glass is made with clay or putty. The corners are also sealed with the same material.

61 Making a panel of irregular shape.

Coloured panels

Prepare a sheet of glass and attach the edging as previously described. Pour an even, thin layer of catalysed resin into the panel mould and allow to cure. Select two or three colours, opaque or translucent, mix in separate small quantities of resin, and add activator and catalyst. On the cured surface of the resin in the panel mould pour a quantity of each coloured resin to produce a small separate pool of each colour. Swirl a rod through the pools mixing one colour with another, but do not overdo this action otherwise the movement of the colours will be completely lost. When the resin has cured the colour movement will be 'locked' in position. Strengthen the panel by adding a layer of glass fibre and clear catalysed resin.

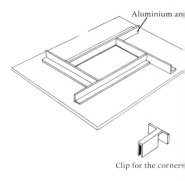

Alternatively, allow the pools of coloured resin to run into one another and cure in their own time.

A variety of experiments can be tried using this way of panel making. There are nearly always quantities of mixed resin left over after all

62 Aluminium angle mould: with this regular shape panels can be made of different sizes.

processes involving its use. These quantities can be poured into poly-ethylene ice-cube moulds and allowed to cure and the coloured lumps of cured resin then saved until a sufficient variety and number are available to use in a panel design. The lumps of resin are placed on the first cured layer of resin. A small quantity of catalysed resin is poured onto the panel to assist the lumps to adhere in the desired position, and finally a layer of resin is poured over to complete the panel.

Panels with embedded composition

A collection of leaves and twigs arranged in a bed of resin can make an interesting composition. The items require to be soaked with resin before being carefully laid in position. Some items, particularly leaves, become translucent while others, like twigs and reeds, remain opaque. It is important to remember this when arranging the composition.

3 Expanded Polystyrene

General

Expanded polystyrene is a solidified foam. The expansion of the polystyrene beads is the result of a chemical action, and when this activity has ceased the volume of the material has considerably increased, a high percentage of it being taken up by air. However, unlike some foams, expanded polystyrene is not porous, but is a structure of cellular spheres with an inert gas trapped inside each one. This gives expanded polystyrene excellent buoyancy and insulatory properties but makes it very difficult to cut with conventional tools. When a saw or knife is used the material crumbles and bits break away.

Expanded polystyrene is thermoplastic, i.e. when heated it softens and if heated sufficiently it will melt.

Cutting

If an electrical current is passed through a wire it will become hot. By carefully controlling the current it is possible to keep the wire constantly at the melting-point temperature of expanded polystyrene, so making it very easy to cut.

Hot wire cutters are available commercially but with a few simple tools, a transformer with a six-volt tapping and some nichrome wire a cutter can easily be made. Hot wire cutters may be connected to a six- or twelve-volt battery and this method is preferable for children. Adequate through ventilation is essential.

Using a hot wire cutter

When using the wire cutter, it is important to keep the work moving at a constant pace: as soon as the wire stops moving the narrow cut widens because the heat continues to melt the expanded polystyrene. If the wire is left long enough in one position, a hole will be formed.

The hotter the wire the quicker the expanded polystyrene must move past the wire.

63 Hot wire cutter with exchangeable blades.

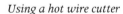

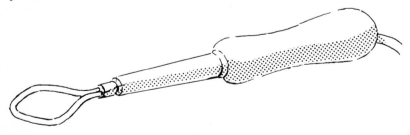

64 Hot wire cutter produced in the workshops.

Working at temperatures only just above the melting-point of expanded polystyrene allows material to move slowly past the wire and give the operator time to control the cutting action. The hot wire must be kept at the 'black heat' stage, as overheating causes toxic fumes.

A lot of general cutting can be done on the model illustrated. The size of material that can be cut is limited by the size of the frame and length of the hot wire. However, design projects can be fabricated in small units

and assembled at a later stage. The pieces can be joined with a polyvinyl acetate (p.v.a.) adhesive or with polystyrene adhesive.

Hollow shapes are best cut with a cutting tool that can be plugged into the hot wire machine. The curvature of the hollow is influenced by the shape of the blade that is used.

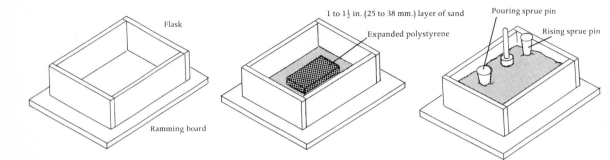

Aluminium casts from expanded polystyrene

This process does require specialist equipment but it is well within the scope of a school or college workshop. If facilities are not available a nearby foundry will often accept the responsibility of producing a casting for very little charge above the cost of the material.

Equipment

MOULDING FLASK: a four-sided box with no top or bottom and large enough to allow a minimum of 1 in. (25 mm.) of sand between the pattern and the sides of the flask.

MOULDING SAND: a sand specially suited to maintain its moulded shape and at the same time allow gases to escape during the casting process.

SPRUE PINS: tapered pieces of wood used to make a pouring hole known as the 'runner' and a second hole known as a 'riser'.

VENTING SPIKE: a piece of wire used to spike the sand to improve the permeable qualities of the sand.

CRUCIBLE: a container in which the metal is heated to a molten state.

FURNACE: these are mainly gas and air fired. The type is unimportant providing the temperature at which the metal melts can be easily reached.

CRUCIBLE TONGS: these tongs are so designed to make it possible to lift the hot crucible from the furnace in comparative safety.

METAL: aluminium is by far the most convenient and suitable material for this type of casting. It melts between 650 and 700°C (1200 and 1290°F); it runs very easily and produces good quality castings. Other metals or alloys, of course, can be used but they are not always as tolerant of overheating or slow pouring as aluminium. Also the brasses and bronze alloys require much higher temperatures to render them in a molten state for casting.

65 Stages in preparing a sand mould.

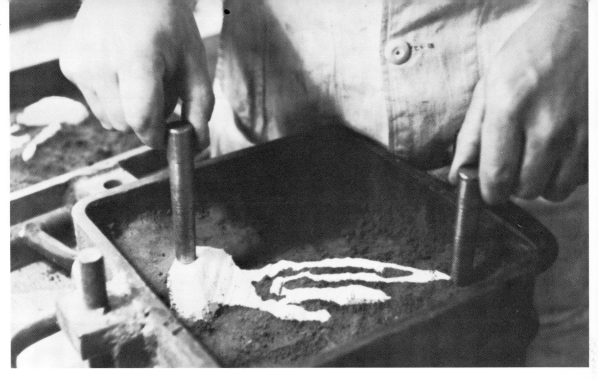

66 Positioning the sprue pins.

Metal casting must be carried out on a concrete floor with dry sand round flask in case of spillage. Also, protective clothing, face mask and gloves must be worn.

The room must be thoroughly ventilated.

Preparing the flask

The principle is to 'replace' the polystyrene form with an aluminium one, the latter reproducing the shape and texture of the former. The hot wire cutter produces a smooth surface. A textured one can be made by use of a surform or coarse metalworker's file. (It is advisable to do this in a well-ventilated room to avoid inhaling dust.) The completed object can then be used as a pattern and packed in a casting flask with moulder's green sand.

Since the pattern is not a split one and will not be removed from the sand a single flask can be used. For large work a flask can be made from four boards 1 in. (25 mm.) thick, fastened together firmly at the corners. The flask can be placed on the floor near to the crucible furnace and a $1\frac{1}{2}$ in. (38 mm.) layer of casting sand rammed level to receive the expanded polystyrene pattern. Clean, sifted casting sand is carefully sprinkled and packed round the pattern remembering not to ram the sand very hard in case the pattern is damaged. A rising and a pouring sprue pin is placed in position and sand packed round them to keep them upright. More sand is rammed carefully into the flask and the surplus sand is strickled flat with a piece of flat steel bar. If the pattern is large and intricately shaped vents are required, they can be made with a venting rod. The sprue pins are removed and the sand made firm round the edge of the holes left by the pins to prevent it from falling into the casting

75

when the molten metal is poured in. Finally, a small pouring basin is carved next to the runner with a small channel joining the two. When the molten aluminium is poured into the basin, the flow into the runner can then be controlled.

The expanded polystyrene pattern must be completely covered with sand. It is advisable to have at least 1 in. (25 mm.) thickness of sand between the pattern and the flask to prevent the wooden sides from burning during the pouring process.

Melting the aluminium

Cut the aluminium ingot into convenient sizes for packing into the crucible. (Make sure enough aluminium is prepared to complete the casting.) Heat the packed crucible in the furnace. When the aluminium has melted a dross is formed on the surface, and this should be skimmed off with a long-handled ladle before pouring. Should the suppliers recommend that the molten metal be degassed, this is the time when it should be done. A degassing tablet is added to the melt and held submerged with a steel rod called a plunger, designed to keep the tablet at the bottom. A bubbling reaction continues for several minutes. When this has ceased dross forms on the surface. This may then be skimmed off and the metal is ready for pouring.

67 Flask placed in a 2 in. (50 mm.) bed of sand ready to receive the molten aluminium.

Process

The metal is poured into the pouring basin and allowed to flow steadily into the runner. Gases are given off almost immediately and soot flakes can be seen floating in the air. This process, therefore, should only be done in a well-ventilated room.

The polystyrene completely vaporizes as soon as the molten metal comes into contact with it and is replaced by the metal. When this has solidified the sand can be removed and the casting brushed to remove the burnt black sand that clings to the surface. The sprue holes will also be faithfully produced and should be sawn off and the sawn surface carefully smoothed or blended to match the surrounding area.

The expanded polystyrene pattern will be completely reproduced by the molten metal even down to the surface texture, provided that the moulding process was properly carried out. There should be no air pockets between the expanded polystyrene and the casting sand. The air supports combustion and a sooty deposit is left on the casting.

The metal casting can be polished where required and other areas left rough or textured to give a contrast and a variety of surface finishes.

68 Aluminium casting from the expanded polystyrene pattern on page 75.

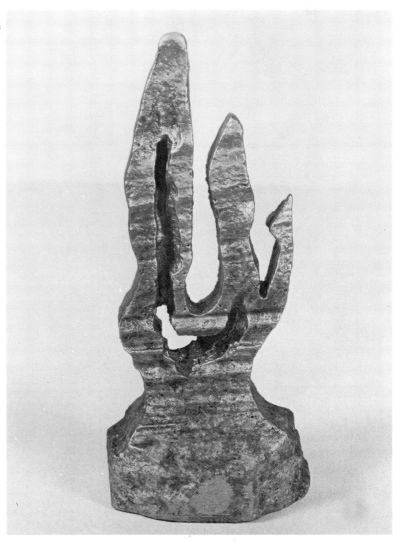

The advantages of the expanded polystyrene casting technique are:
1. The material is easy to shape.
2. Shapes cut out of expanded polystyrene can be added to the basic shape with a suitable adhesive.
3. The shape of the final pattern is not governed by draft and undercuts.
4. The casting can be done in a single flask and not two as normally used in foundry work.

The disadvantage of this process is that only a single mould can be cast and, therefore, it is essential that every stage is thoroughly completed to ensure success. Minor flaws can be treated on the object. A major flaw of course means going back to the beginning and starting with new material and trying to produce a similar shape to the original. However, the process is simple and failure is rare.

a

b

c

d

e

Points to remember

It is difficult to calculate the amount of casting metal required for irregular shapes. Experience helps to assess the amount required for the melt so for the beginner it is advisable to melt more metal than is actually required. This is preferable to discovering part way through the pouring process that there is insufficient metal to complete the casting, as it is not possible to heat more metal and pour it into the mould later. The first pouring will have solidified and prevent the new supply of molten metal from flowing to all areas of the mould. The process must be completed in one operation.

The characteristics of the casting produced by this method are almost unique and only equalled by castings produced by the lost wax process. If it were not for a rather lengthy title, the process described might be referred to as 'the lost expanded polystyrene process' since the two are so alike.

Basic process

1. Carve expanded polystyrene.
2. Prepare flask with a layer of sand.
3. Place carving on the sand.
4. Sift clean sand over the casting and pack into every corner and crevice.
5. Place sprues.
6. Complete packing.
7. Withdraw sprues.
8. Pour metal.
9. Remove casting from sand.

Pendants from expanded polystyrene casting technique

Method

First a design is made from expanded polystyrene, either with a hot wire cutter or with a piece of wire heated in a flame. The hot wire cutter

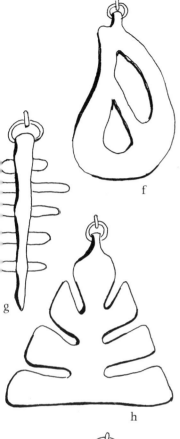

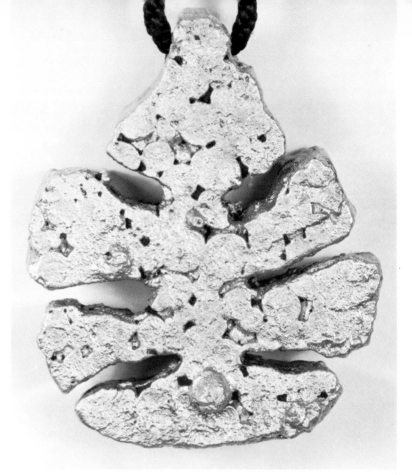

is suitable for cutting the external shapes and the heated piece of wire is suitable for making holes and cutting away internal shapes.

The work is then embedded in casting sand with a sprue pin, the sprue pin removed and aluminium poured in the mould.

There is no need for a second hole to allow the molten metal to rise.

Warning: There should be at least 2 in. (50 mm.) of sand above the work so that the column of molten aluminium in the pouring hole has sufficient weight to force the metal into the mould.

Possible shapes

Design (a) The centre of this design has a hole so that embedding resin and an object of interest can be embedded in the final work. The techniques are described in chapter 2.

Design (b) This is made from a number of bits of expanded polystyrene glued together using a P.V.A. adhesive.

Designs (c) and (d) can be made the same way as (b) or made from a single piece of expanded polystyrene and scored on the surface with a hot wire.

Designs (e), (f), (h) and (i) are made by using the hot wire cutter and a heated piece of wire.

Design (g) is made by glueing pieces together.

69 Pendant designs.

79

Flasks—There is no need to use foundry flasks for casting small work such as pendants. A tin can with the top cleanly cut away is ideal for the purpose of casting. A useful size of can is 5 in. (125 mm.) tall by $3\frac{1}{2}$ in. (87 mm.) diameter.

A layer of sand is pressed firmly in the base of the can, the work placed centrally and sand packed round the sides to keep it in place. A sprue pin is then placed in a convenient position on the work and more sand is packed round the work and the sprue pin. Small vents are made with a piece of wire and the sprue pin removed.

Sufficient aluminium is melted in a small crucible or ladle on a gas ring and poured into the mould.

When the work has cooled it is removed and the burnt sand in the crevices brushed away.

4 Injection Moulding

General

The injection moulding process has until recently been the prerogative of industry, most of the thermoplastic items about us being processed by this method. It is ideally suited to mass production techniques and as yet little thought has been put into its creative possibilities.

Small hand-operated injection moulding machines are now available and some educational establishments have been using them for several years. It would appear that the main use of these machines at the moment has been in the production of draughts, golf tees, cabinet knobs, doorstop moulds and small wheels. Each of the items mentioned are functional

71 Injection moulding machine.

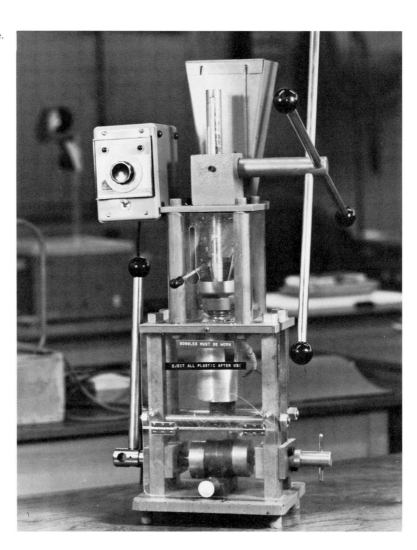

items but seem to show little or no prospects for the use of the imagination. However, designing a die, even for the most mundane item, is a demanding mental activity. An understanding of the types of gates and the flow qualities of the plastics to be used is essential before any attempt is made to produce one.

Safety precautions

1. The machine must be securely fixed to a bench.
2. Moulds must be made of suitable material that will withstand temperatures up to 300°C (572°F) and pressures up to 4,500 lb. p.s.i. (315 kg./cm².).
3. Only inject when the guard is in position.
4. Goggles or protective visors must be worn.
5. Do not use unidentified plastics.
6. Use only dry plastics.

Designing a die

The features of a die must permit a flow of molten plastics under pressure to enter the die, flow into the cavity and, when solidified, be able to be extracted.

This is a way to make a simple die to fit a hand-operated machine: the size of the die is determined by the capacity of plastic material that can be injected in one operation and the size of the vice in which the die is held. The capacity of the machine illustrated is $\frac{3}{4}$ oz. (21 grammes) and the outside dimensions of the die must not exceed $4 \times 4 \times 1\frac{1}{2}$ in. ($100 \times 100 \times 37$ mm.) which means that the end product is quite small: a split die for a wheel some 2 in. (50 mm.) in diameter uses the maximum amount of plastics.

MATERIAL: steel, brass, aluminium, are metals that are suited to the manufacture of a die for injection moulding. The highest temperature to which the die will be subjected is approximately 250°C (482°F), which should have no adverse effect on any of the metals mentioned.

PROCESS OF MANUFACTURE: this is best done mainly on a metal-worker's lathe providing that the injected shape is also round in section.

OTHER FEATURES: in order that the injected shape can be removed it is necessary for the die to be made in two parts. Complicated dies may be made of many parts.

LOCATING PIN: when the two halves of a die are brought together it is important that they always lock in one position.

Materials suitable for injection moulding are powders made of acrylic, polystyrene, polypropylene, polyethylene, polyvinyl chloride, nylon, a.b.s. (acrylonitrile-butadiene-styrene).

Process

Pour clean dry moulding powder into the hopper, then feed a quantity sufficient to fill the heating chamber into the heating chamber from the

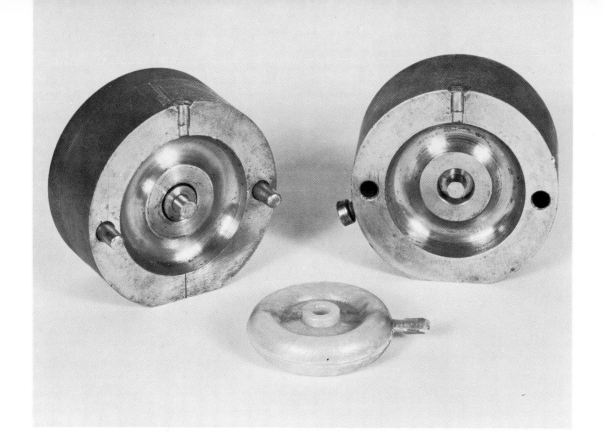

72 Split die for making a wheel 2 in. (50 mm.) in diameter. Note the locating pin and the gate through which the plastic is injected.

hopper and pack it tightly with a ram controlled by the movement of the cross levers. Set the thermostatically controlled switch to the recommended temperature (see list) and switch on.

Next, clamp the mould in the vice and carefully line it up with the nozzle.

When the thermostatically controlled switch turns off (this is indicated by a red light on most switches) it is time to inject the now very soft plastics into the mould.

This action should be a continuous movement and constant pressure on the cross levers should be maintained until a complete resistance is felt. This moment often coincides with the soft plastics oozing from between the nozzle and the mould, which indicates that the mould is full. Do not release the pressure immediately. Hold the cross levers for a short while to allow the plastic to solidify partly then release the pressure and allow the nozzle to return to its elevated position.

Remove the mould from the vice (asbestos gloves will be required), open the mould and eject the moulding.

Faults and remedies

Fault: mould only partially full.
Remedy: maintain a constant flow of material into the mould. If the fault persists, increase size of gate.

83

Fault: wrinkled surface.
Remedy: preheat the mould before injecting the plastics.

Fault: difficult to eject moulding from the die.
Remedy: lightly oil the surface of the die before injecting the plastics.

Fault: flash (excess plastics).
Remedy: see that there is nothing to prevent the halves of the die meeting perfectly. Tighten the vice.

Better quality mouldings are produced if the mould is heated before being used. When a mould is cold the molten plastic chills on entry and begins to solidify prematurely.

Suggested temperatures for heating the mould when using different plastics:

Material	Mould temperature
Polyethylene	30 to 50°C (86 to 122°F)
Polystyrene	30 to 80°C (86 to 176°F)
Polypropylene	50 to 60°C (122 to 140°F)
Nylon	85 to 100°C (185 to 212°F)

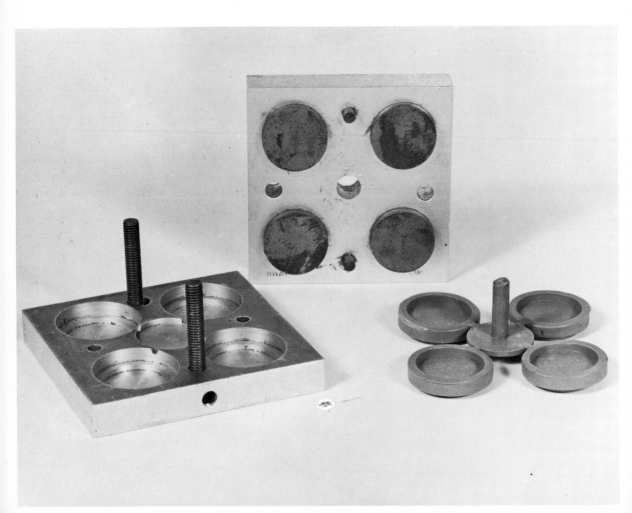

73 A split die for making draughts, design and made by Michael Williams, sixth form student at Filton High School.

Suitable temperatures for moulding differ for different materials, and this temperature should be given on the packet, or on a leaflet of instruction issued by the manufacturer.

Approximate temperatures are listed below and should only be used as a guide:

Nylon Polyethylene }	190° to 220°C (374 to 428°F)
Polystyrene	200°C (392°F)
Polypropylene	250°C (482°F)

Further applications: production of construction kits.

5 Pendants from Vacuum Formed Moulds

Vacuum forming process

In this process a flat sheet of thermoplastic is heated until it is soft and then sucked over a mould by removing the air. The sheet must be clamped in an air tight frame so that all the air can be removed between the sheet and the mould.

The Satra vacuum forming machine consists of a heating unit, a clamping frame and a hand operated vacuum pump and is quite suitable for a young person to handle.

Clamp a sheet of thermoplastics in the frame. Lift the hinged frame to the vertical position where it will be parallel and adjacent to the heater. Place a mould on the vacuum bed. Switch on the heater and within approximately two minutes the sheet begins to soften so that ripples form in the soft thermoplastics. They will be seen to radiate inwards to begin with and then move to a parallel vertical position only seconds later. When this stage has been reached the sheet is soft enough for vacuum forming. Bring down the frame to the horizontal position over the mould, clamp it to the vacuum bed, and quickly withdraw the air from the machine with the hand operated vacuum pump. Stop pumping as soon as the soft thermoplastics has taken up the shape of the mould. Lift the formed sheet off the mould almost immediately and take it out of the clamping frame. When the edges are trimmed, the forming operation is complete.

Designing a mould

The two most important features of any mould are:
1. That all the air can be extracted, i.e. there are no hollows where air can be trapped.
2. That the mould can be extracted from the formed sheet.

Moulds can be made from wood, plaster, metal or a thermosetting resin, the choice being dependent mainly upon availability of materials and facilities for working. Wood is perhaps the most commonly used material for making moulds and the descriptions that follow will, therefore, refer to moulds made from wood.

Blocks of wood that have their corners slightly rounded and their vertical sides slightly tapered constitute the simplest form of mould.

A number of these blocks of varying sizes and proportions can be carefully arranged on a sheet of hardboard which will fit inside the vacuum machine. The blocks are then glued in position. Holes approximately $\frac{1}{16}$ in. (1 mm.) diameter are drilled through the hardboard in the positions shown, and the mould is ready for use.

A sheet of p.v.c. 18 in. (450 mm.) long
10 in. (260 mm.) wide by $\frac{1}{32}$ in.
(75 mm.) thick being heated in a
vacuum forming machine.

A sheet of p.v.c. vacuum formed over
mould (photographs courtesy of
Shoe and Allied Trades Research
Association of Kettering).

Common faults

1. The thermoplastics does not completely pull down on the mould.
Possible reasons:
 1. The thermoplastics not quite soft enough.
 2. An air leak between the clamping frame and the vacuum bed.
 3. A badly designed mould; more vents required.
2. The thermoplastics breaks over the mould.
 1. A wrong or faulty thermoplastics is being used.
 2. A sharp or pointed edge on the mould.
3. Creasing:
 1. The mould is too deep.
 2. Insufficient space between high areas.

Remedies:

For 1

1. Reheat the thermoplastics.
2. Ensure that the frame is properly clamped to the vacuum bed.
3. Increase the number of vents particularly in the region where the thermoplastics failed to form round the mould.

For 2

1. Use another sheet.
2. Remove sharp or pointed edges with glasspaper.

For 3

1. Use a shallower mould.
2. Increase the space between high areas.

Moulds for pendants

The principle of this technique is to make a mould from the thermoplastic sheet by vacuum forming and then cast resin shapes from it.

While a variety of thermoplastics can be used in a vacuum forming machine, not all of them are suitable for resin. Styrene, for example, is attacked chemically by resin within minutes of contact, becomes soft and eventually tears. Polyvinyl chloride (p.v.c.) on the other hand is ideal: it does not react with resin and does not deteriorate noticeably with use.

To produce a pendant mould a wooden pattern of the pendant has to

76 Preparing a mould for vacuum forming.

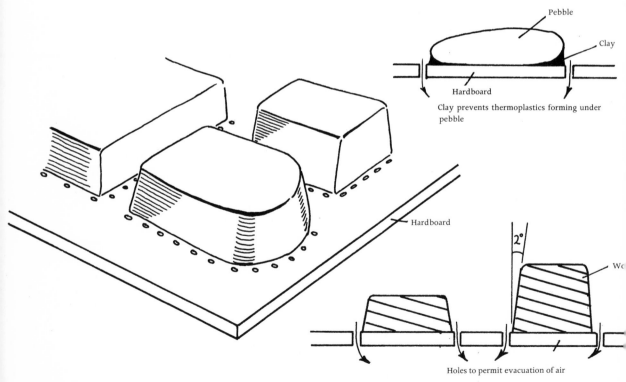

Pebble

Clay

Hardboard

Clay prevents thermoplastics forming under pebble

Hardboard

2°

Wo

Holes to permit evacuation of air

Section through mould to show draft and position of air evacuation holes.

be produced first. Carefully shape the wood, allowing a draft of approximately 2° on the sides so that the wooden pattern can be easily removed from the p.v.c. mould at a later stage in the process.

Since the sheet for vacuum forming in the machine illustrated is 18 × 10 in. (450 × 250 mm.) it is advisable to make a number of wooden patterns in a variety of shapes to make full use of the sheet. Place the patterns on a base board, and draw a pencil line round each one. After removing the patterns, drill holes approximately $\frac{1}{16}$ in. (1·5 mm.) diameter and $\frac{1}{2}$ in. (12 mm.) apart along the lines. Replace the patterns and hold them in position either with a dab of glue or by pinning them from the underside of the base board. If they are pinned from the top through the pattern, punch the head of the pin below the surface level and fill the small hole with a suitable wood filler and finally rub it smooth with glass paper. Any marks on the pattern will be faithfully reproduced in the vacuum formed p.v.c. and ultimately in the resin casting.

Pebbles can also be used as patterns for making a casting mould, as the natural shapes are often very attractive and suitable for pendant shapes. The vacuum forming sheet must not, however, be allowed to enclose the pebble otherwise it will not be possible to remove it without damaging the p.v.c. sheet. This can be prevented by moulding some clay or plasticine underneath the pebble.

Before casting it is advisable to apply a parting agent to the tray. This not only assists in the removal of the resin from the mould but helps to prevent it attacking the mould.

acuum formed mould for casting
ı forms of which there are two
nples on p. 55.

Some ideas for pendants:

1. Partly fill the mould with clear resin and allow it to set. Place a coloured lump of cured resin in the first layer and fill the remainder of the mould with a clear or tinted resin.

2. Partly fill the mould with clear resin and allow to set. Place an arrangement of aluminium turnings or brass chips from a lathe and add a second layer of resin to just cover the metal. When the second layer has set add a third layer containing a colouring pigment to act as a background to the centre of interest of the pendant.

3. Proceed the same as in 2, except for the final layer. Instead of adding coloured resin place a piece of coloured acrylic sheet on the first layer. The acrylic must be brought into contact with the resin before it has set so that a natural bond will take place between the two.

89

6 Coating Metals with Plastics

The process of applying a coat of plastics to a metal has, at the moment, essentially a practical application only. Yet, if attitudes and ideas develop, there is no reason why this process should not be used creatively.

The means of applying a plastic covering to a metal was a major breakthrough at the time of discovery, as many years of research had ensued before the process was completely successful. The discovery of how to produce plastics in powdered form helped enormously. It enabled the development of a process in which hot metal is dipped into the powder and the clinging particles of the powdered plastic then melt and fuse together to encapsulate the metal. The thickness of the coat, however,

78 A fluidizer with a clear acrylic front which enables the process to be seen.

varies considerably within a single coating, often being thickest around the edges and very thin in the middle of a flat area.

When a German firm, Knapsack-Griesheim, used a process known as 'fluidization' for coating metals with plastics considerable improvement on the distribution of the plastic coating over the metal was observed and this has since become one of the main processes by which metals are coated with plastics.

Fluidization

This term is used to describe what happens to a powdered material when air is gently blown through it: when particles of the powdered material are at rest they behave like a solid, but when air is passed through them, they behave like a fluid. Hence the name fluidization.

These changing characteristics of the powder are easily demonstrated. While the powder is at rest a piece of metal and a piece of wood are placed adjacent on it, and are supported by it. Air is then gently blown through the powder, and the volume increases; the metal sinks into the powder, while the wood remains on the surface as if it were floating.

Dip coating

PREPARATION OF THE ARTICLE: The article should, of course, be as clean as possible. Dirt, rust or any loose particles should be removed. If at all greasy the article should be rubbed with a cloth dipped in tri-chloroethane.

HEATING: An electric domestic oven is ideal for this purpose. The metal article must be heated to approximately 300°C (572°F). It must also be possible to remove the article from the oven and to suspend it in the fluidizer. This is done by attaching a thin fuse wire to a part that is not being coated, or to an inconspicuous part, then bending the unattached end into a hook or loop so that the item can hang freely when cooling. It is important that the object, when coated with the powdered plastics, does not come into contact with anything while it is hot. Even if no damage is caused to the object it touches, the plastic coated surface will most certainly be harmed.

The length of time required for the object to remain in the oven will depend upon the object's size. Small objects usually take 4 or 5 minutes, while bulky pieces of work may take as long as 20 minutes. This time factor must be determined by trial and error.

DIPPING: Remove the object from the oven, suspended by a piece of fuse wire, and dip it in the fluidizer, which contains the air-blown powder (see over for how to make one). The article must be completely submerged for approximately five seconds to allow the hot metal to melt the powdered plastics on its surface and to allow time for more powder to fuse together. A gentle movement through the powder is believed to assist in a uniform coverage of the article. When the object is withdrawn from the fluidizer the surface will appear still in powder form. On small items it is necessary to return the article to the oven for a minute to completely melt the powder and produce a smooth finish, while on large

items that have plenty of mass the residual heat may be sufficient to melt the plastics to produce a smooth surface, in which case it is not necessary to return the article to the oven.

COOLING: When the surface of the plastic coating is smooth and uniform the article may be hung in a convenient place to cool. Quenching in water is not advisable.

The fuse wire will, of course, be partly buried in the plastic coating. It should be neatly clipped off as near to the surface as possible and any marks smoothed over with a heated piece of clean metal or spatula.

Faults and how to remedy them:

POWDER NOT ADHERING TO THE SURFACE: Either the cleaning process on the metal was not thorough enough, or the article was not hot enough, in which case it must be returned to the oven.

POWDER ADHERING TO PARTS OF THE OBJECT: This again suggests that the cleaning operation was not sufficiently thorough. Allow the work to cool, scrape off any plastics and begin the process again, ensuring first that the article is properly clean.

PIN HOLING: The article was not held in the fluidizer long enough to allow sufficient powder to melt on to the surface. If the pin holing was minimal the article should be dipped in the powder a second time. If very bad all the plastic coating should be removed and the process started again.

UNEVEN COATING: This is often caused by insufficient volume (not pressure) of air passing through the powder. The volume of air must be increased.

If all operations have been faithfully carried out and coating is still unsuccessful, then the powder must be contaminated. Remedy—discard the powder and start with fresh clean stock.

The fluidizer should have a lid and when it is not being used the lid should be closed. Dust from the air in sufficient quantity is able to reduce the efficiency of this process.

Making a fluidizer

MATERIALS:
4 pieces of plywood, $\frac{3}{4}$ in. (18 mm.) thick, 16×10 in. (500×300 mm.)
2 pieces of plywood, $\frac{3}{4}$ in. (18 mm.) thick, 10×10 in. (300×300 mm.)
8 battens of softwood 10 in. $\times \frac{5}{8}$ in. $\times \frac{1}{4}$ in. (300 mm. \times 15 mm. \times 6 mm.)
1 porous tile, 1 in. (25 mm.) thick, 10×10 in. (300×300 mm.)
1 vacuum cleaner
1 dozen countersunk screws 1 in. (25 mm.) No. 6
2 dozen $\frac{3}{4}$ in. (19 mm.) panel pins

A useful size fluidizer should be able to contain 5 to 7 lb. (2·3 to 3·2 kg.) of powdered plastic when air is passed through it.

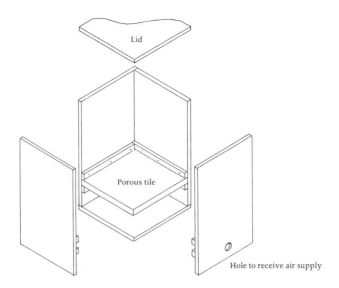

Lid

Porous tile

Hole to receive air supply

79 Exploded view of a fluidizer to show construction.

PLASTIC POWDERS: A number of plastics can be produced in powder form. The list includes:
high density polyethylene
low density polyethylene
cellulose acetate butyrate
polyvinyl chloride
nylon 11 (Rilsan) derived from castor oil.

COLOURS: These are rather limited at the moment but with further knowledge and experience the range should increase.

In order to select a colour for an article it is necessary to have it available in a separate fluidizer. If only one fluidizer is available the coloured powder will have to be changed every time a different colour is required. So, if dip coating is done regularly it is advisable to have a number of fluidizing tanks each with a different colour. Still, only one air supply is needed since it can be easily fitted to the fluidizer containing the required plastic powder. One further disadvantage of having only one fluidizer is that the powders become slightly mixed because of the difficulty incurred in cleaning it out.

Application

POLYETHYLENE: indoor and outdoor furniture, dish drainers, hanging garden baskets.

CELLULOSE ACETATE BUTYRATE: steering wheels of motor cars, hand rails.

POLYVINYL CHLORIDE: mainly electrical fittings.

NYLON: barriers on motorways and medical appliances.

CREATIVE APPLICATIONS: this area has yet to be explored. There is no reason, however, why it should not be used to coat metal sculptures that are placed out of doors, plastic being so much more resistant to corrosive weather conditions.

93

Glossary

ACCELERATOR: sometimes known also as activator or promoter. A liquid chemical added to a resin to speed up the curing process. Some resins are available pre-activated or pre-accelerated. The curing (hardening) process will not take place until the catalyst is added.

ACETONE: a highly volatile liquid used for cleaning equipment covered with polyester resin.

ACRYLICS: the most commonly known acrylic materials are known by the commercial names of 'Perspex', 'Origlas', 'Plexiglas' and 'Lucite'. It is a clear glass-like material, available in liquid and solid form.

ANNEALING: relief of stresses from heating by controlled cooling.

BURR: a dentist's drill.

CASEIN: the first of the thermosetting plastics. A derivative of skimmed milk treated with rennet enzyme. Its main application is as a wood adhesive but is being superseded by synthetic resin adhesives.

CASTING: the pouring of a resin into a mould, or the result of pouring resin into a mould. The term also applies when other materials are used such as metals.

CATALYST: initiates the curing process known also as polymerization. Available as a paste or liquid. In loose terms it is described as a hardener.

CELLULOSE: a carbohydrate, the woody part of plants. Can be converted into celluloid or cellulose acetate. The main source of the food wrapping film 'cellophane'.

CELLULOSE ACETATE: the first plastics material rendered in pellet form for injection moulding (about 1930). Used in the production of plastic model kits until superior materials became available approximately 15 years later.

CELLULOSE NITRATE: the first of the plastics to be developed (in 1868) used as a substitute for ivory in the manufacture of billiard balls. The material was known as celluloid.

CHEMICAL RESISTANCE: unaffected by chemical acids and alkalis.

CHOPPED STRAND MAT: used as a reinforcement in polyester resin. A glass fibre with strands arranged in a criss-cross pattern.

COEFFICIENT OF LINEAR EXPANSION: the linear change of length of a material for a unit change in temperature.

CRAZING: numerous fine cracks often caused by a rapid curing process in which exothermic heat causes stresses within the resin.

CROSS-LINKING: the chemical definition of the curing process in thermo-setting resins. See *polymerization*.

CURING: the hardening or setting process.

DIELECTRIC: resistant to electric currents, i.e. a good insulator.

DIP COATING: the application of a plastic coating to a piece of heated metal. The heated metal is dipped into a tank of powdered plastics known as a fluidizer.

DRAFT: the taper on the side of a pattern or a mould which facilitates removal of a casting.

DROSS: oxidized material that floats on the surface of molten metal.

EDGE GLOW: a quality found in some acrylics that causes the transmission of light through the edges, sometimes referred to as light piping and edge lighting.

ELASTOMERIC (adj.): rubber-like, after stretching it returns to its original form and dimension.

EMBEDDING: setting an object in resin. Other names: potting, encapsulating and setting.

ENCAPSULATING: see *embedding*.

EXOTHERM: the amount of heat given off in a chemical reaction such as the curing of a polyester resin.

EXTRUSION: the result of a granulated thermoplastics being heated and forced through a die.

FEMALE MOULD: a hollow or concave mould.

FILLER: an inert substance often in powder form added to a liquid resin to improve the physical properties such as hardness.

FLASH: excess plastics formed along the meeting point of two dies on a mould.

FLASH POINT: the lowest temperature at which combustion is possible.

FLASK: box or case in which sand moulds are made.

FLOW: the movement of a plastics in a semi-fluid state during a moulding process.

FOAM: a rubber or plastics containing numerous pockets of air.

FOAMING AGENTS: chemicals that produce bubbles of gas which, when trapped, form the foam.

GATE: the entrance to a mould or die for plastics in a liquid or molten state.

GEL: a semi-solid state sometimes used to describe the state of a resin during curing.

GEL COAT: the first coat of resin, often pigmented, applied to a mould.

GELATION TIME: the time taken for a resin to become 'jelly like' after the catalyst has been added.

GLASS FIBRE: a mat made from fine strands of glass (see also *Tissue mat*).

GLASS TAPE: a woven glass fibre material usually 1 to 2 in. (25 to 50 mm.) wide used for reinforcing resins.

GREEN STAGE: a stage in the curing of resin, when it is firm but slightly pliable.

HARDENER: a loose term describing a catalyst used to promote the polymerization or curing of a resin.

INHIBITOR: a chemical (solid, liquid or gas) which retards the curing process of resin.

INJECTION MOULDING: a process in which a thermoplastics is heated and forced by a ram or screw through a nozzle into a mould or die.

INORGANIC PIGMENTS: colouring agents derived from natural or synthetic metallic oxides.

KERF: a cut made by a saw.

LAMINATE: layers of resin-soaked, glass fibre paper or cloth, bonded together, either by the polymerization of the resin or by means of heat and pressure, to form a single piece.

LAY UP: the process of coating a mould with resin and a reinforcing material.

LIGHT PIPING: see *edge glow*.

MALE MOULD: a mould with a raised convex working surface.

MASK: to protect a surface from contact with an adhesive or abrasive.

MELAMINE: a synthetic resin made from the reaction of melamine and ureaformaldehyde, a clear thermosetting plastics.

MELT: a foundry term to describe a crucible of molten metal.

METHYL-ETHYL-KETONE-PEROXIDE (MEKP): a catalyst sometimes known as a hardener, used to start the curing process of polyester resin.

METHYL METHACRYLATE: a thermoplastics commercially known as 'Perspex', 'Oroglas', 'Plexiglas' or 'Lucite'. A derivative of acrylic acid.

MONOMER: a compound that can react to form a polymer.

MOULD RELEASE AGENT: sometimes referred to as a parting agent. Used to prevent a resin sticking to the surface of a mould.

NYLON: a polyamide, usually made into fibres by the process called melt spinning.

OPTICAL QUALITY: of material especially enhanced by light.

ORANGE PEEL: a term used to describe the surface finish of a material, and often regarded as a defect.

ORGANIC PIGMENTS: colouring pigments that are usually bright but unable to retain their brilliance as long as inorganic ones.

PARTING AGENT: the same as a release agent: see *mould release agent*.

PARTING LINE: the line left on a moulded object from a split mould or die.

PLASTIC (adjective): a temporary or permanent characteristic of a material.

PLASTIC MEMORY: after reheating, some thermoplastics return to their original form. The ability to return to original form.

PLASTICIZER: substances used to make plastics more flexible.

PLASTICS (noun): man-made materials derived mainly from coal and oil. The term plastics is used because at one stage of their production they were in a plastic state. There are two broad classifications: thermoplastics and thermosetting plastics. See definitions.

PLASTISOLS: emulsions or solutions of polyvinyl chloride and responsible for promoting a wide variety of characteristics. They assist greatly in providing the necessary properties for hot-dip coating and slush moulding.

POLYAMIDE: a thermoplastics, e.g. nylon.

POLYESTER: a thermosetting resin (in the context of this book).

POLYMERIZATION: the process whereby small molecules in a long chain form larger molecules. The hardening or curing process.

POLYSTYRENE: in the pure state a transparent and very brittle thermoplastics, but polystyrene beads heated with a foaming agent expand into a 'solid foam'. In the commercial field this light-weight material is used both as an insulator and as a package material, but in the creative field it is excellent for carving with a hot wire cutter and being used as a one-off pattern in sand casting.

POLYVINYL CHLORIDE: one of the most widely used thermoplastics, and better known as p.v.c. Available in a wide variety of forms, both as a flexible and a rigid material.

POSITIVE MOULD: a male mould.

POT LIFE: the period of time a catalysed resin remains liquid.

PROMOTER: See *accelerator*.

REINFORCED PLASTICS: plastics containing a reinforcement such as glass fibre.

RELEASE AGENT: see *mould release agent*.

RISER: a hole in a sand casting which allows both the escape of air and gases given off during the pouring process and the molten metal to rise when the mould is full.

SETTING TEMPERATURE: the temperature required for a resin to set. This process is usually inactive at temperatures below 4°C (40°F) and almost inactive at temperatures only just above it. A good setting temperature is 18°C (65°F). Above this temperature the setting time is considerably decreased.

SHELF LIFE: the period of time a liquid resin will remain liquid at average room temperature. Shelf life is decreased in warmer temperatures and increased in cooler temperatures. The shelf life of a resin is approximately 12 months if kept in a cool place. Not to be confused with *pot life*.

SHRINKAGE: the thermal contraction that takes place when a resin polymerizes. Reduction in volume.

SINTERING: the fusing together of powdered plastics by the application of heat. The powdered particles are not melted.

SLURRY: a thin coating of plaster or clay, usually heavily diluted with water.

SLUSH MOULDING: a mixture of plastics and plasticizer is poured into a mould and rotated. A viscous skin forms on the side of the mould and hardens.

SOLVENT: one substance that will dissolve another. Commonly used in plastic adhesives or cements.

SPRUE PIN: a tapered, cylindrical piece of wood used to form the hole for pouring molten metal in a sand casting. A second tapered cylindrical piece of wood is also used to provide the riser.

STIPPLING: a prodding action with a stiff-haired brush.

STRICKLE: a foundry term used to describe the levelling off of sand from a flask.

SURFORM: an abrasive cutting tool used for cutting irregular shapes.

SWARF: the waste produced when cutting a material.

THERMOFORMING: a method of moulding objects from thermoplastic sheets. See *vacuum forming*.

THERMOPLASTICS: a family of plastics that can be softened by the application of heat and made to change their form.

THERMOSETTING: used to describe a family of plastics that cannot be melted. They set hard and remain hard.

THIXOTROPIC: a resin capable of remaining on a vertical surface. At rest these resins are gel-like but quite fluid when stirred.

TISSUE MAT: made from very fine strands of glass, usually used as a final or top layer after a coarser glass mat has been used to reinforce a resin.

UNDERCUTS: the parts of a mould that prevent easy removal of a casting. In such cases a split mould or a flexible mould should be used.

UNSATURATED RESIN: in the context of this book, a resin which will react with a catalyst.

VACUUM FORMING: method of forming a thermoplastic sheet on a mould by heating the sheet until it is soft and withdrawing the air beneath it when it is clamped around the mould.

VENT: a small hole to allow the escape of gas or air from a mould.

VENT ROD: a piece of wire used to produce small diameter holes in a sand casting.

WASHER ROLLER: a roller consisting of a number of large and small washers used for eliminating air from the lamination of glass fibre and resin.

WORKING LIFE: the period of time in which a catalysed and activated resin remains workable. See *gelation time*.

WOVEN ROVINGS: a closely woven glass fibre cloth.

Identifying Plastics

There are so many types of plastic materials available today and so many of them are very similar in appearance that it is difficult for the layman to differentiate one sample from another. By the combination of polymers with a single main one the characteristics of the single polymer change. Nylon is one such example and there are no less than one hundred varieties of nylon. So many new varieties are developed each year that it would be impossible to give a list of plastics with identification features that would be of value and always up to date.

By referring to the flow diagram opposite and carrying out the simple tests it is possible to gain some knowledge of the material being identified.

A sliver is cut from the sample with a penknife. If the sample was difficult to cut the chances are that it is a thermosetting plastics, i.e. it belongs to the same family as the resins used for casting and embedding in this book. If the sliver is powdery then this is most certainly a thermosetting plastics. A further test, putting the powdery sliver into a flame, will help to establish the type of thermosetting plastics. The flame from a candle, a spirit burner or a gas torch is ample for this test.

Some firms produce identification kits in which as many as a dozen to twenty samples are numbered in a case. The numbers on the samples relate to the indentification of the plastics on a printed list and help the beginner to identify materials through familiarity with known plastics and the sense of touch, sight, smell and sound.

It is important to know the characteristics of the material with which you are working. A wrong identification can result in a piece of work being spoilt by use of the wrong adhesive, or even the wrong process.

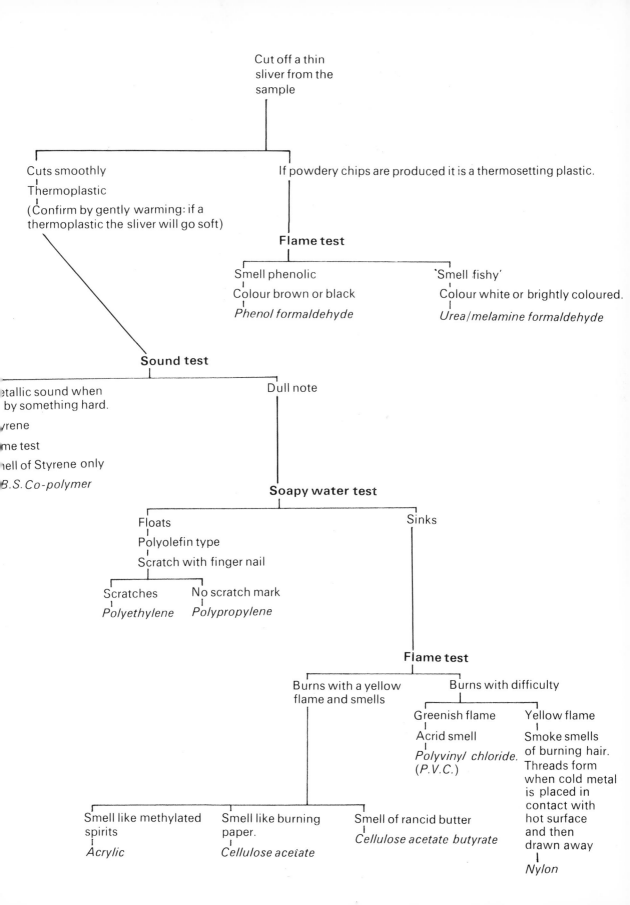

Cut off a thin
sliver from the
sample

Cuts smoothly

Thermoplastic

(Confirm by gently warming: if a
thermoplastic the sliver will go soft)

If powdery chips are produced it is a thermosetting plastic.

Flame test

Smell phenolic

Colour brown or black

Phenol formaldehyde

'Smell fishy'

Colour white or brightly coloured.

Urea/melamine formaldehyde

Sound test

etallic sound when
by something hard.

rene

me test

ell of Styrene only

B.S. Co-polymer

Dull note

Soapy water test

Floats

Polyolefin type

Scratch with finger nail

Scratches

Polyethylene

No scratch mark

Polypropylene

Sinks

Flame test

Burns with a yellow
flame and smells

Burns with difficulty

Greenish flame

Acrid smell

Polyvinyl chloride.
(P.V.C.)

Yellow flame

Smoke smells
of burning hair.
Threads form
when cold metal
is placed in
contact with
hot surface
and then
drawn away

Nylon

Smell like methylated
spirits

Acrylic

Smell like burning
paper.

Cellulose acetate

Smell of rancid butter

Cellulose acetate butyrate

Manufacturers and Suppliers

A note on acrylics

The solid acrylics are obtainable in sheet, tube, rod and block form. The sheets are supplied with a protective paper covering so that the high glossy surface does not become damaged. When buying sheets it is advisable to only purchase those with the protective cover on both sides. If the paper has peeled away from the corners or edges inspect the surface of the acrylic sheet for scratch marks before purchasing.

Because of the increased demand upon plastics in general, suppliers are plentiful. Many of them carry out two main functions, (1) to supply plastics as a raw material to builders, designers, artists, engineers, sculptors, educationalists, etc. (2) To carry out contracts for display and advertising or any work which involves the use of plastics.

Suppliers generally carry a very wide range of plastics and acrylics may form only one section of a supplier's stock. However, it is usually quite comprehensive and can more than satisfy the needs of the average customer.

Clear acrylic sheet is obtainable in thicknesses from $\frac{1}{16}$ to 1 in. (1 to 25 mm.) in standard sheet sizes from 3×3 ft. (900×900 mm.) to 12×6 ft. ($3 \times 1 \cdot 80$ m.). The $\frac{1}{8}$, $\frac{3}{16}$, and $\frac{1}{4}$ in. (3, 4·5, 6 mm) thickness sheets are by far the most commonly used and no difficulty should be experienced in obtaining these. The supplier will cut a standard size sheet to a particular size but this will increase the cost per square unit. If, however, you are buying a standard size sheet and you wish it to be cut in half the supplier will probably do this as part of the service and without an increased charge.

Acrylic sheet is also available in a wide range of attractive translucent and opaque colours, opal and patterned surfaces. Since there are several shades of any one colour it is advisable to have a catalogue plus a set of samples so that you can be sure of obtaining the correct one. I.C.I. have a name and a code number for all the coloured, opal or patterned acrylic sheet so that ordering can be done by quoting the code number only.

Acrylic blocks can be obtained in standard size sheets ranging from 1×1 ft. (300×300 mm.) to 6×4 ft. ($1 \cdot 8 \times 1 \cdot 2$ m.) in thickness between $1\frac{1}{4}$ and 5 in. (32 and 127 mm.).

Extruded acrylic round bar is available in diameters from $\frac{1}{8}$ to 2 in. (3 to 50 mm.). Cast acrylic round bar is available in diameters from 2 to 12 in. (50 to 300 mm.).

Acrylic seamless tube is available from 3 to 6 in. (75 to 150 mm.) outside diameter with a wall thickness varying from $\frac{1}{8}$ to $\frac{1}{4}$ in. (3 to 6 mm.) in standard lengths of 6 ft. (1·80 m.) Longer lengths are available but not so readily obtainable.

Australia

Deans Artcraft Pty Ltd (retail), 368 Lonsdale Street, Melbourne, Victoria 3000

F & M Agencies (retail), 101 Regatta Road, Southport, Queensland 4215

Handcraft Supply Pty Ltd, Rear 33 Brighton Avenue, Croydon Park, NSW 2133

Marcus Art Pty Ltd (retail), 122 Pelham Street, Carlton, Victoria 3053

Max Muller Pty Ltd (retail), 5 Westward Street, Wavell Heights, Queensland 4012

New Standard Radio (retail), 114 Hunter Street, Newcastle, NSW 2300

Richman Art Centre (retail), Station Arcade, Box Hill, Victoria 3128

Southland Newsagency (retail), Southland Shopping Centre, 1239 Nepean Highway, Cheltenham, Victoria 3192

Steeland's (retail), 38 George Street, Parramatta, NSW 2150 and 186 Forest Road, Hurstville, NSW 2220

Wollongong Handcrafts (retail), 305 Crown Street, Wollongong, NSW 2500

Great Britain

The British Plastics Federation, 47 Piccadilly, London W1V 0DN, have an information bureau. The Plastics Institute, 11 Hobart Place, London SW1W 0HL, publish a number of useful pamphlets.

British Industrial Plastics Ltd, 28 Haymarket, London SW1 *or* Popes Lane, Oldbury, PO Box 11, Warley, Worcs.

BP Chemicals International Ltd, Educational Service, West Halkin House, West Halkin Street, London SW1

Bakelite Xylonite Ltd, Enford House, 139 Marylebone Road, London NW1 5QE

Ciba-Geigy (UK) Ltd, Plastics Division, Duxford, Cambridge CB2 4QA

Dunlop Ltd, Education Section, 25 St James's Street, London SW1

Du Pont Co. (UK) Ltd, Du Pont House, 18 Breams Buildings, Fetter Lane, London EC4

Imperial Chemical Industries Ltd, Plastics Division, Bessemer Road, Welwyn Garden City, Hertfordshire

Lennig Chemicals Ltd, Lennig House, 2 Mansons Avenue, Croydon, London

London Art Bookshop (retail), 72 Charlotte Street, London W1

Shell Chemicals UK Ltd, Shell Centre, London SE1

Trylon Ltd, Thrift Street, Wollaston, Wellingborough, Northamptonshire NN9 9RL

School suppliers: materials

BDH Chemicals Ltd, Poole, Dorset BHL2 4NN

Griffin & George Ltd, Easling Road, Alperton, Wembley, Middlesex HA0 1HJ

Smith Brothers Asbestos Co. Ltd, Wellington Street, Leicester *and* 89–91 St George's Road, Bristol 1

Trylon Ltd, Thrift Street, Wollaston, Northants NN9 7QJ

School suppliers: equipment/machines
Florin Ltd, 457–463 Caledonian Road, London N7
Fox & Offord Ltd, Alma Street, Aston, Birmingham B19 2RP
M. L. Shelley & Partners Ltd, St Peter's Road, Huntingdon PE18 7HE
The Small Power Machine Co. Ltd, 368a Northolt Road, South Harrow,
 Middlesex

USA

Acrylic sheet
Cadillac Plastic, 148 Parkway, Kalamazoo, Michigan
Cast Optics Corporation, 1966 South Newman Street, Hackensack, New
 Jersey 07602
Plastics Sales Inc., 863 Folsom Street, San Francisco, California
Rohm and Haas Co., Independence Mall West, Philadelphia,
Pennsylvania 19105

Catalysts
Apogee Chemicals Inc., DeCarlo Avenue, Richmond, California
McKesson and Robbins, Chemical Department, 155 East 44th Street,
 New York 10017
Wallace and Tiernan Inc., Lucidol Division, 1740 Military Road,
 Buffalo, New York 14240

Hot wire cutters
Dura-Tech Corporation, 1555 North West First Avenue, Boca Raton,
 Florida
The Plastics Factory, 119 Avenue D, New York, New York 10009

Plastic sheets, rods and tubes
Commercial Plastics and Supply Corporation, 630 Broadway, New
 York 10012

Polyester and epoxy resins
Reichhold Chemicals Inc., RCI Building, White Plains, New York
Shell Chemical Co., Plastics and Resins Division, 110 West 51st
 Street, New York 10020
Taylor and Art Inc., 1710 East 12th Street, Oakland, California 94606
The Plastics Factory, 119 Avenue D, New York, New York 10009

Polystyrene
Sinclair-Koppers Co., Koppers Building, Pittsburgh, Pennsylvania
 15219

Vacuum forming machines
O'Neil-Irwin Manufacturing Co., Lake City, Minnesota
Orbit of California, 211 Los Molinos, San Clemente, California 92672
Montroy Supply Company, P.O. Box 74335, Los Angeles, California
 90004
Dymo-Form Division, Dymo Products Co., Box 1030, Berkeley,
 California 94701
AAA Plastic Equipment Inc., P.O. Box 11512, Fort Worth, Texas 76110
Wesflex Machine Co. Inc., 8 Lois Street, Norwalk, Connecticut 06851

Plastic kits
The Craftool Co., 1 Industrial Road, Woodridge, New Jersey

Study and workshop programs in plastics
The Plastics Factory, 119 Avenue D, New York, New York 10009

Safety when using Plastics

This is not a comprehensive account of the dangers of using plastics but the increased use of plastics such as GRP (glass-reinforced plastics) sheet and foamed material introduces the possibility of new dangers in school or home workshops. The range of these materials available for use need not be restricted unnecessarily if safe methods of handling are encouraged. These methods are not difficult or expensive to put into operation but it is necessary to be aware of the potential hazards which may occur whilst using these materials. These may be considered under the following headings:

1 hazards to the respiratory system
2 hazards to the eyes
3 hazards to the skin
4 fire and explosion hazards.

General recommendations for workshop safety must be followed, especially those relating to electrical safety where the use of machines, ovens, heaters, hot-wire cutters, etc., is involved. Manufacturers' instructions regarding hazards associated with various plastics materials should be obeyed.

1 Respiratory hazards

Work with plastics, as with aerosols, paints and sprays, should not begin unless there is adequate ventilation of the area. The ventilation should be sufficient to maintain a supply of fresh air in the work area at all times.

Harmful vapours or gases may be produced through the evaporation of solvents and the breakdown of the materials through the application of heat, and it is necessary to ensure that their concentrations are kept as low as possible. Inhalation of toxic gases may have delayed reactions, so that danger is not immediately apparent.

a The production of articles in GRP results in the liberation of styrene fumes into the air. Provided that only small quantities are being used in any one area and that it is well ventilated, the styrene fumes are not likely to reach harmful concentration. If larger mouldings are to be produced, for example boat hulls, some form of forced ventilation is necessary, especially when working inside the hull. It should be remembered that the solvent concentration is likely to be greater in hot weather

due to the higher evaporation rate. Ventilation should be increased by opening all available doors and windows.

b Cutting expanded polystyrene by means of a hot wire generates styrene fumes. This should be carried out only in well ventilated conditions so that a low concentration of vapour is obtained. Styrene fumes may irritate the eyes and cause dizziness if concentrated, although this depends to some extent on personal susceptibility. Children appear to be more prone to this hazard than do adults and it is therefore recommended that ventilation should be generous in every case. The hot wire should be so constructed as to operate at an even temperature, below red heat.

c When casting aluminium using expanded polystyrene patterns, it is essential that good venting of the mould be provided in order to minimize the risk of an accumulation of gas.

d The production of polyurethane foam from liquid materials produces toxic gases, and it is advised that this procedure should be carried out only in the open air and under the control of an experienced adult.

e Solvent de-greasing should not be carried out with solvents such as petrol, alcohol, ethers, ketones, etc. Not only are many of these highly flammable; some of these are also highly toxic. Carbon tetrachloride, whilst non-flammable, is highly toxic and should not be used. Trichloroethane is suitable for small de-greasing operations but good ventilation is essential.

f Precautions must be taken when machining or abrading most materials to prevent excessive inhalation of dust and small particles. Like some timbers and ceramics, many plastics are inherently dusty. Adequate ventilation is essential and inexpensive disposable masks should be provided. Dust produced on work with GRP can be reduced if the material is trimmed whilst in the 'green' stage.

2 Eye hazards

Apart from dust, the eyes are at risk from waste particles of plastics and from organic liquids. For all operations involved in machining of plastics, provision of positive eye protection (goggles or shield) is essential.

Organic peroxides which are used as catalysts for curing GRP will cause severe damage if in contact with the eye. Measuring and mixing of the catalyst should be done only under the direct supervision of the teacher, using a standard dispenser which is constructed to prevent squirting of the liquid. The dispenser is calibrated to allow a quantity of liquid to be accurately measured.

If, despite all precautions, it is suspected that the eye has been in contact with catalyst it should be washed immediately with plain water or a 2% aqueous solution of sodium bicarbonate. IN ALL CASES A DOCTOR SHOULD BE CONSULTED WITHOUT DELAY.

3 Skin hazards

a Dermatitis risk is present with the use of resins, especially with epoxy and polyurethane resins, which should be used only under strict control. Good washing facilities should be available and any resin contamination should be washed off at once. Exposed areas of skin should be protected with a barrier cream before starting work. This is necessary even when disposable polyethylene or PVC gloves are used, e.g. for dipping processes. The use of a proprietary cream to cleanse the skin is prudent, but the use of solvents, such as acetone, for this purpose should be avoided, since successive degreasing can result in harmful effects to the body.

b The temperatures involved in plastics moulding and shaping are lower than those for various comparable metal processes. Nevertheless, attention must be drawn to the dangers of allowing molten plastics to come into contact with the skin. These dangers arise from the high heat capacity of molten plastics and from the fact that they stick to the skin and are therefore difficult to remove. Protection can usually be afforded by the use of thick, dry industrial gloves.

4 Fire and explosion hazards

a All plastics materials should be stored in cool, dry conditions. Such materials as catalysts (organic peroxide) and accelerator (cobalt naphthanate) should be stored in separate, preferably metal, cupboards. The storage of large quantities of catalysts, resins and cleaning fluids will not only increase the fire hazard but will also tend to shorten the shelf life of the material. A three-months stock may generally be considered to be sufficient, economic and safe. Organic peroxides should be stored in vented containers, away from any flammable materials and should not be placed in the sun or near any heat source. Catalysts and accelerator should never be mixed directly, as this would produce a violent reaction and possibly an explosion.

b The disposal of large quantities of waste plastics is of course a matter for the specialist. In schools, only small quantities are likely to be involved. However, waste material should not be left in the workshop but should be removed and burned as soon as possible. Any surplus catalysed resin should be spread out to prevent high heat concentration and a possible fire. Spillages of resin should be covered with sand and removed to open ground whenever possible. Small spillages, however, may be mopped up with rags or paper and burned as soon as possible. On no account must rags be used to mop up miscellaneous materials, as mixtures of peroxide and accelerator may then occur, leading to fire or more violent reaction.

c Foamed material, unless specifically made fire-retardent, is highly flammable and must be stored with care away from open flames or other heat sources.

5 General safety notes

a All electrical connections should conform to standard regulations, and should be made only by a competent electrician.

b Rather than a mains supply, it is preferable to use batteries (6 or 12 V) with hot-wire cutters, especially if the cutters are used by primary pupils.

c A chemical trap for the sink is advised as the sink is likely to be used for washing off resins and other chemicals. Accumulation of materials does not then occur in the drains.

d Adequate protective clothing should be worn by all pupils using plastic materials.

e A first-aid box, equipped to deal with burns and cuts and for washing off catalyst, should be provided in the area where plastic materials are used.

Bibliography

Arundel, Jan *Exploring Sculpture* Mills & Boon, London and Charles T. Branford Co., Newton Centre, Massachusetts 1971

Bunch, Clarence *Acrylic for Sculpture and Design* Van Nostrand Reinhold Co., New York 1972

Clarke, Peter J. *Plastics for Schools* Allman & Sons, London 1970

David, Walter (ed.) *Glass Fibre Construction for the Amateur* Isopon Inter-Chemicals, London 1970

Know Your Materials—Plastics Model & Allied Publications, Hemel Hempstead, Hertfordshire 1970

Lewis, G. M. and Warring, R. H. *Glass Fibre for Amateurs* Model & Allied Publications, Hemel Hempstead, Hertfordshire 1961

Newman, Thelma *Plastics As an Art Form* Pitman & Sons, London 1965 and Chilton Book Co., Philadelphia, Pennsylvania 1969

Newman, Thelma *Plastics As Design Form* Chilton Book Co., Philadelphia, Pennsylvania 1972

Roukes, Nicholas *Crafts in Plastics* Watson-Guptill Publications, New York 1970

Roukes, Nicholas *Sculpture in Plastics* Watson-Guptill Publications, New York 1968

Trylon Polyester Handbook Trylon Ltd, Wollaston, Wellingborough, Northamptonshire

Tysoe, Peter *Glass Resin and Metal Construction* Mills & Boon, London 1971

Zechlin, Katharina *Setting in Clear Plastic* Taplinger Publishing Co., Inc., New York 1972 and Mills & Boon, London 1971

Technical Literature of a helpful kind may be obtained from:

 Imperial Chemical Industries Ltd, Plastics Division, Bessemar Road, Welwyn Garden City, Hertfordshire

 Lennig Chemicals Ltd, Lennig House, 2 Manson's Avenue, Croydon, London

Index